LOVELY LADIES
A COLORING BOOK FOR ADULTS

BY
ASHLEY HOLOHAN

Copyright © 2016 by Ashley Holohan
All rights reserved. Images from this book may be reproduced, scanned,
or distributed in any printed or electronic form for **personal, non-commercial purposes only.**
The artist **MUST** be credited. See back of book for more information.

Printed in the United States of America
ISBN: 978-1536869224

TO ALL THE FOLKS FROM MY ART STREAMS.

YOU ALL INSPIRE ME!

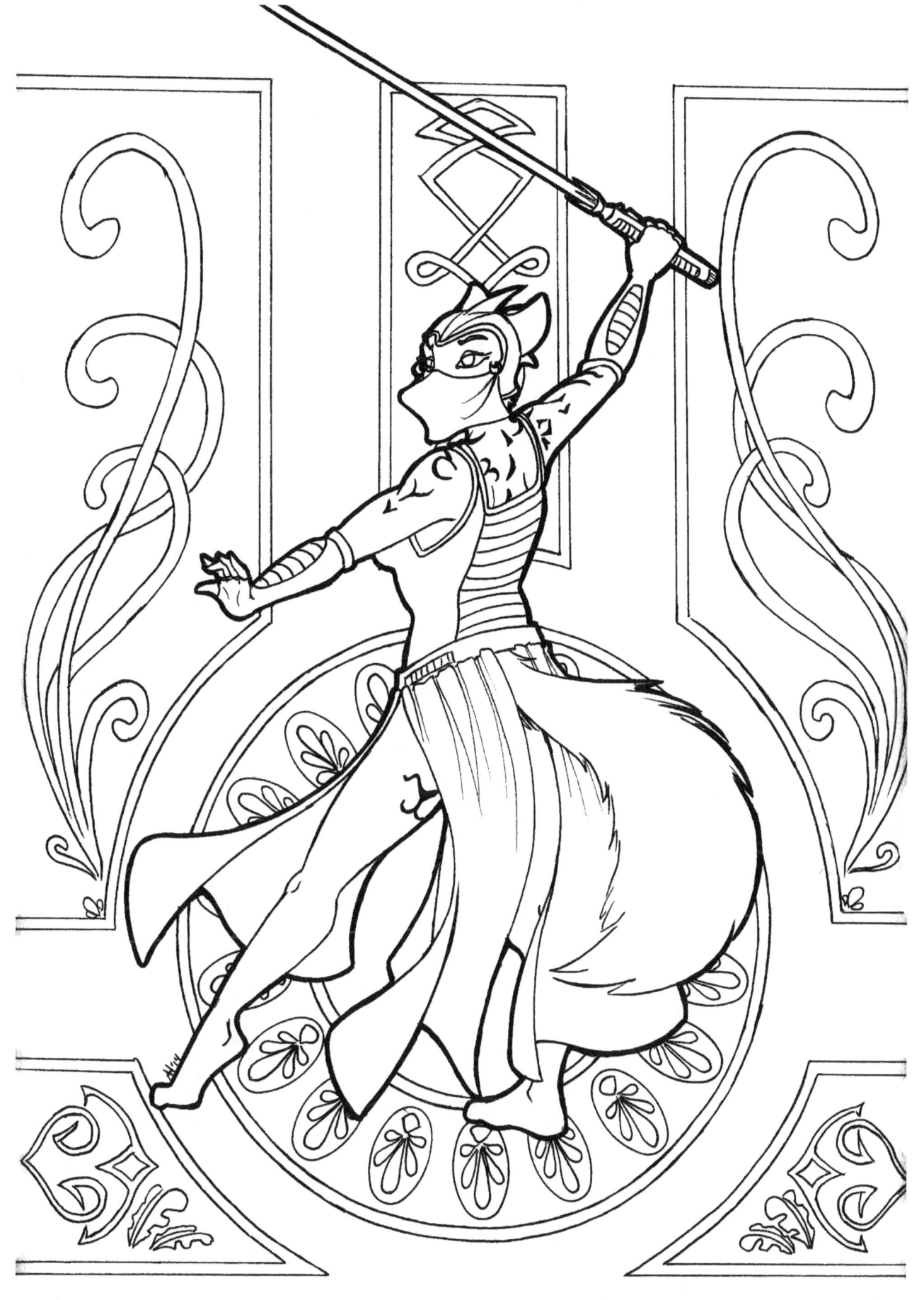

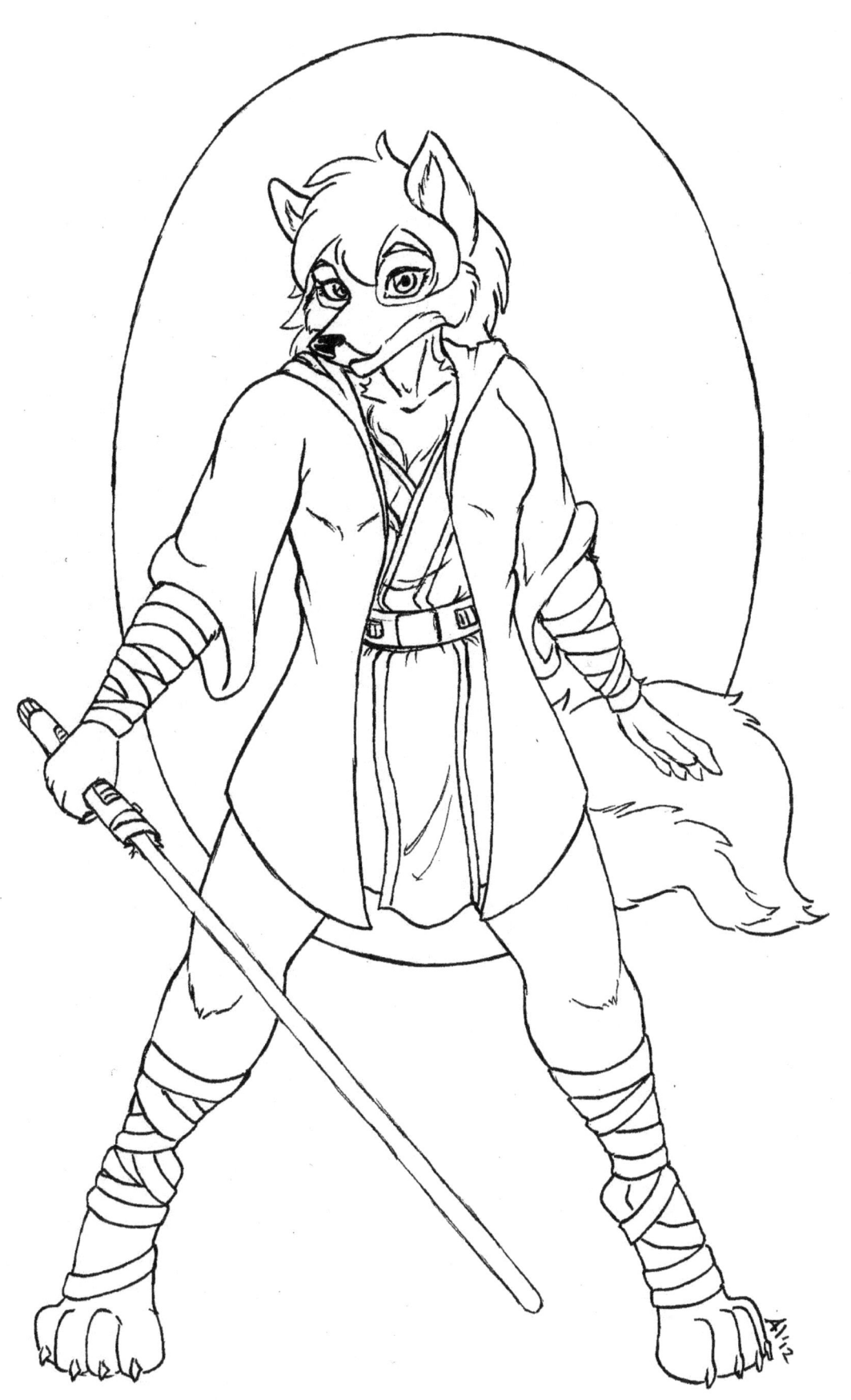

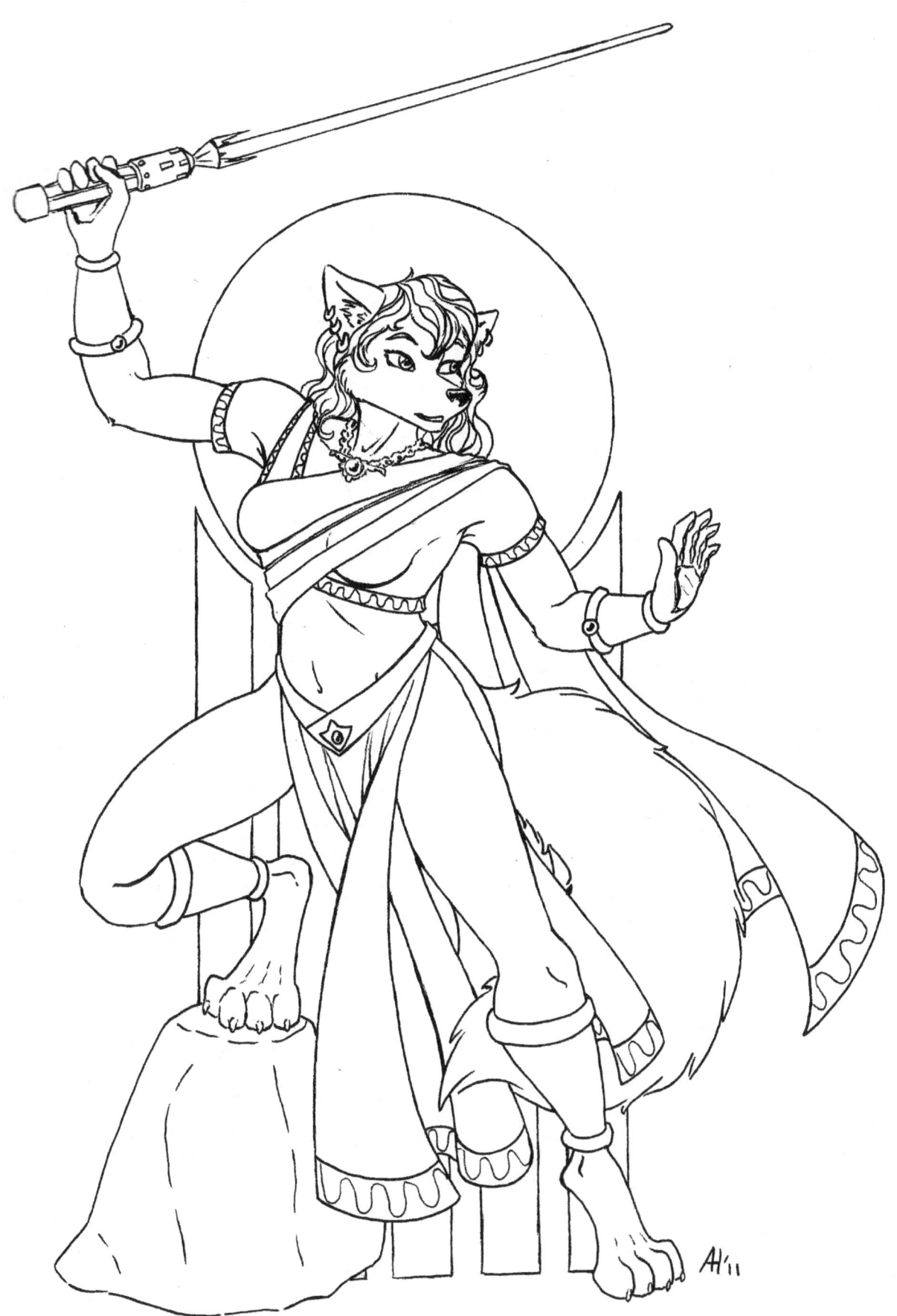

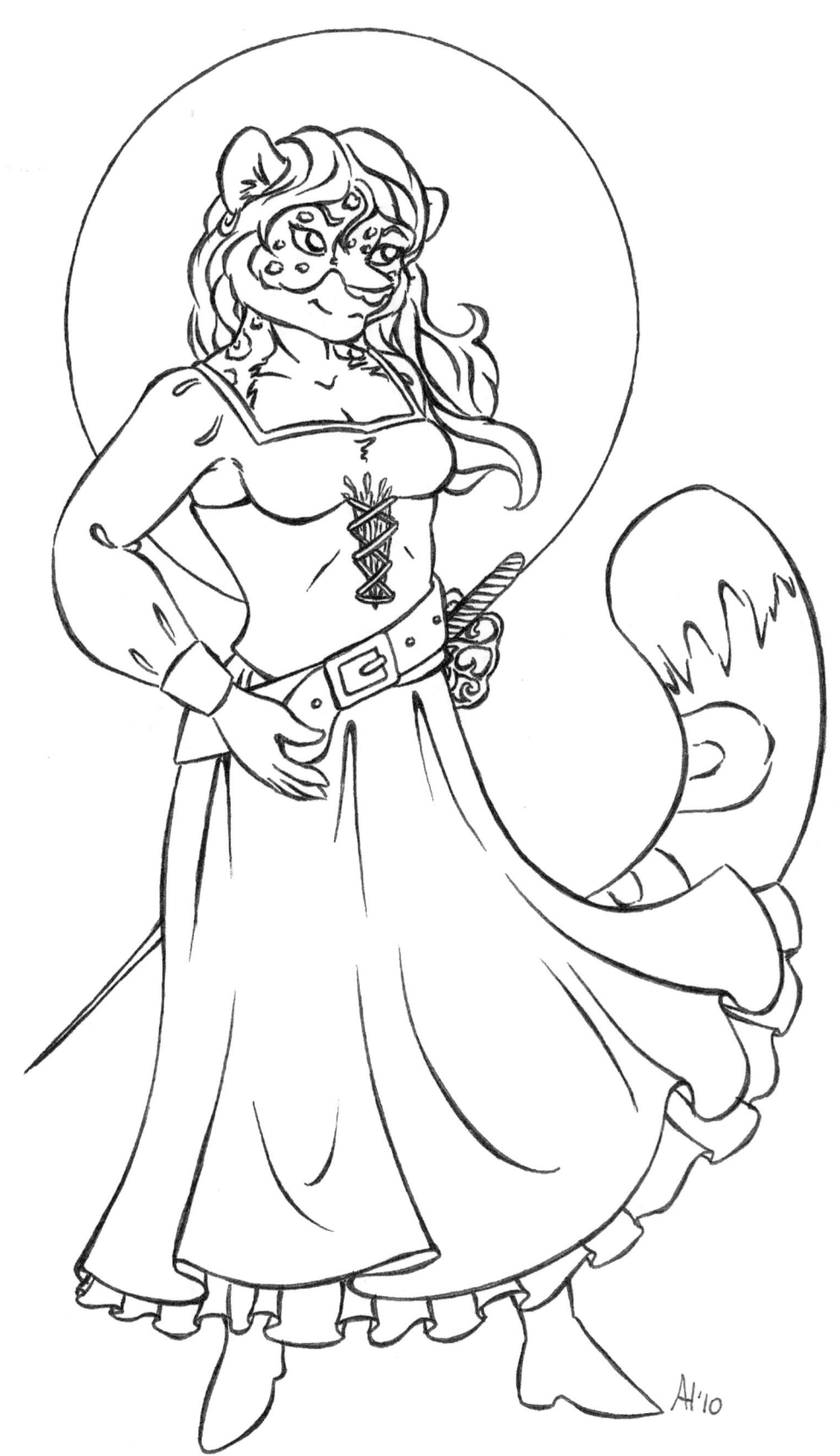

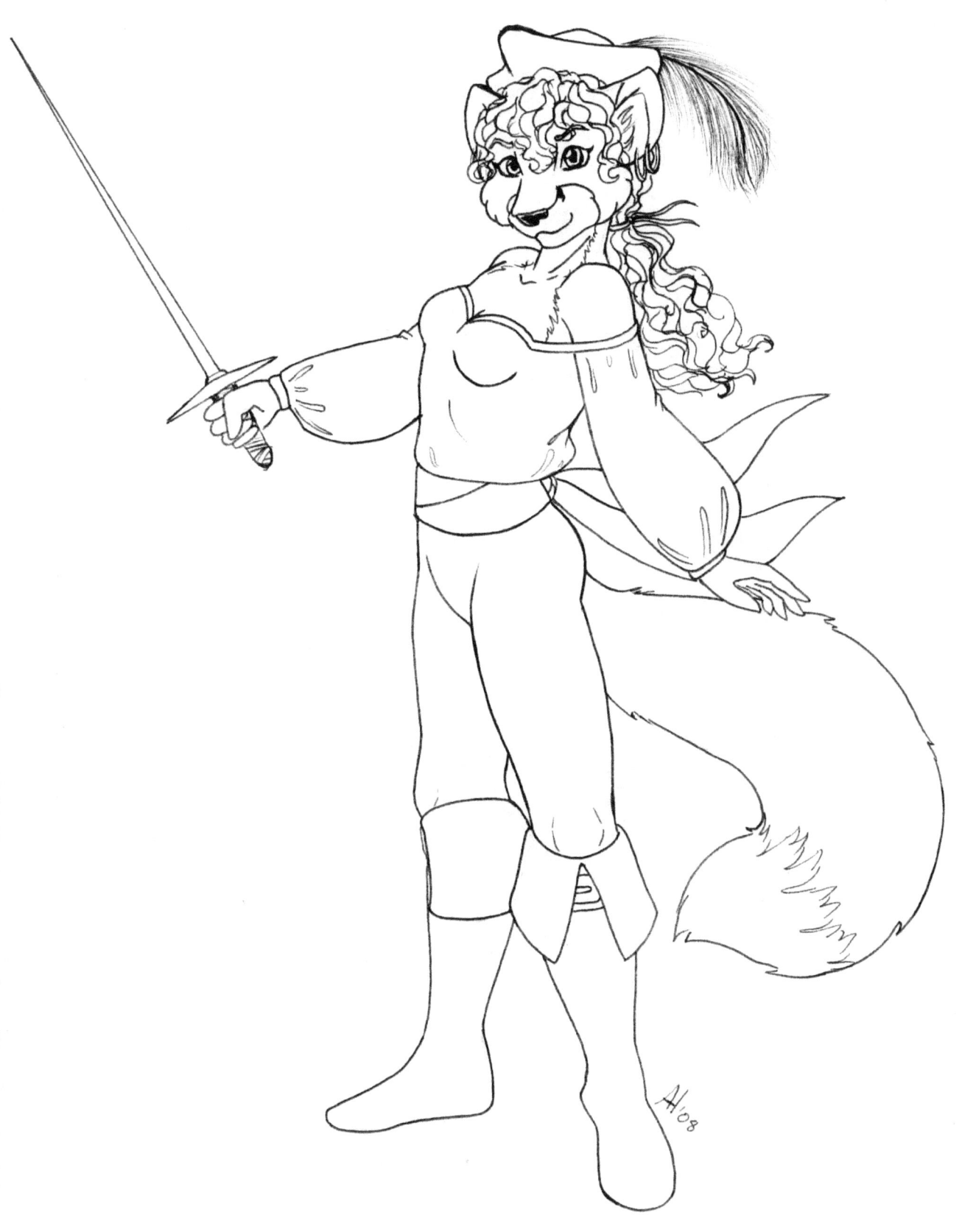

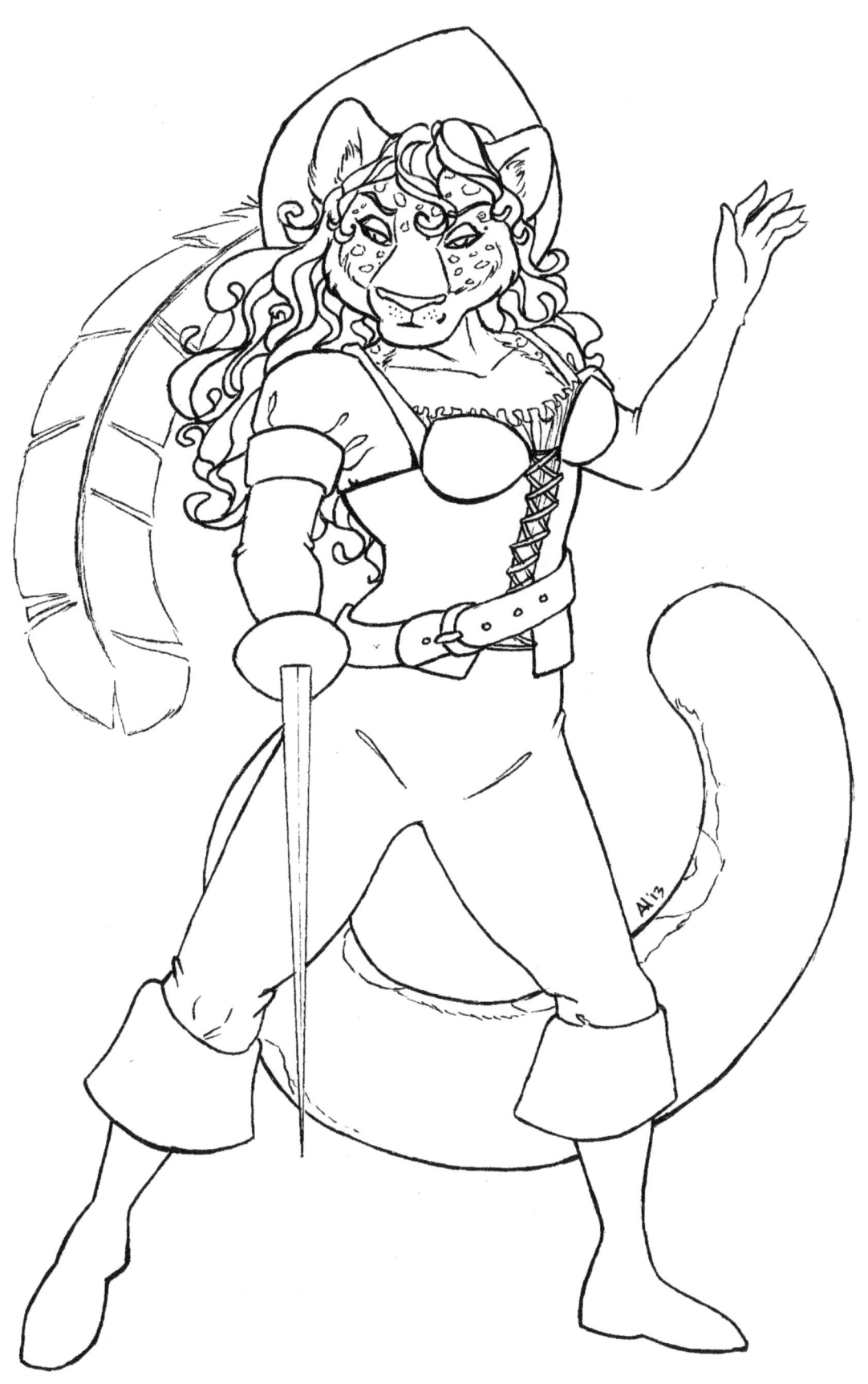

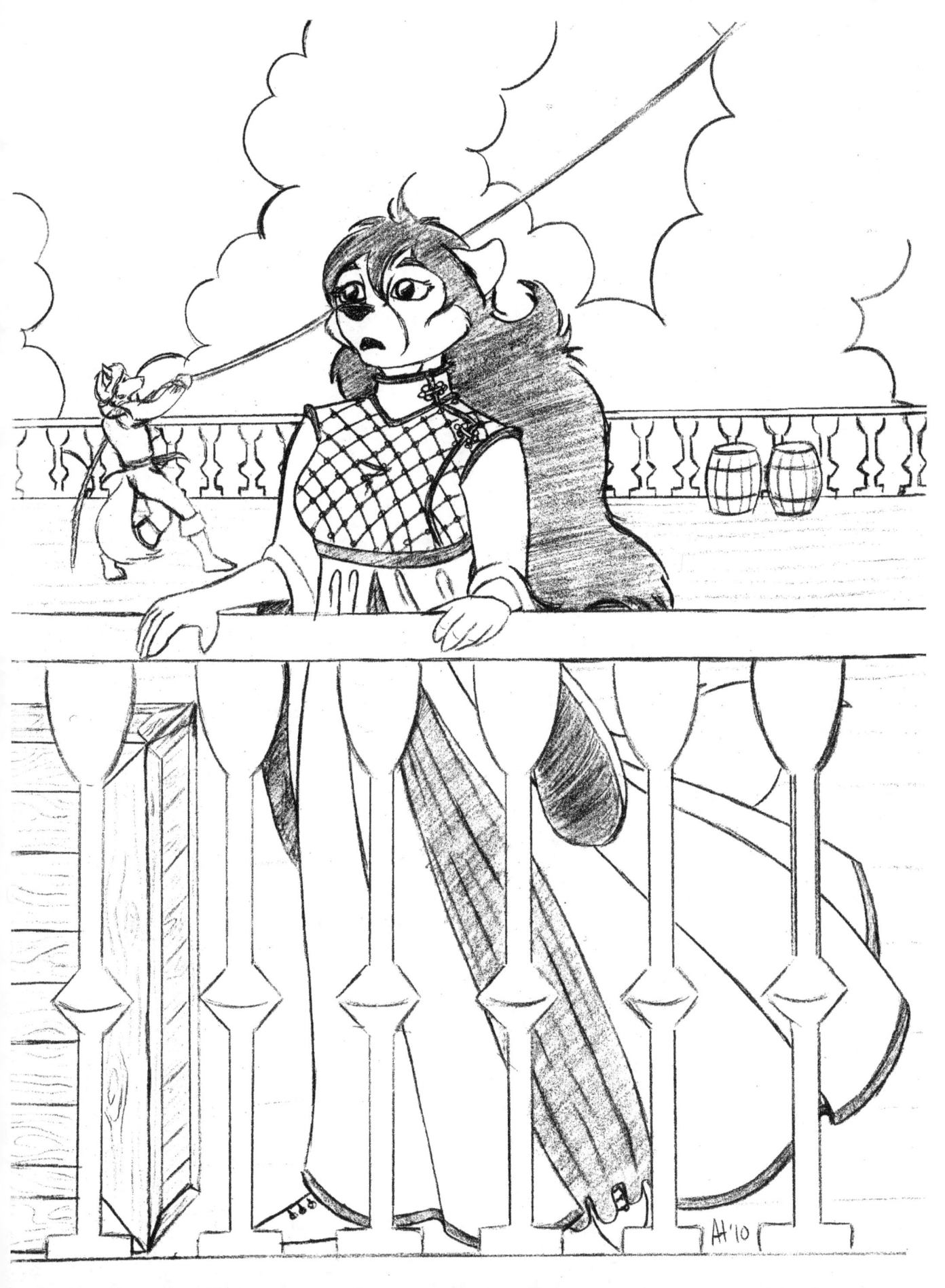

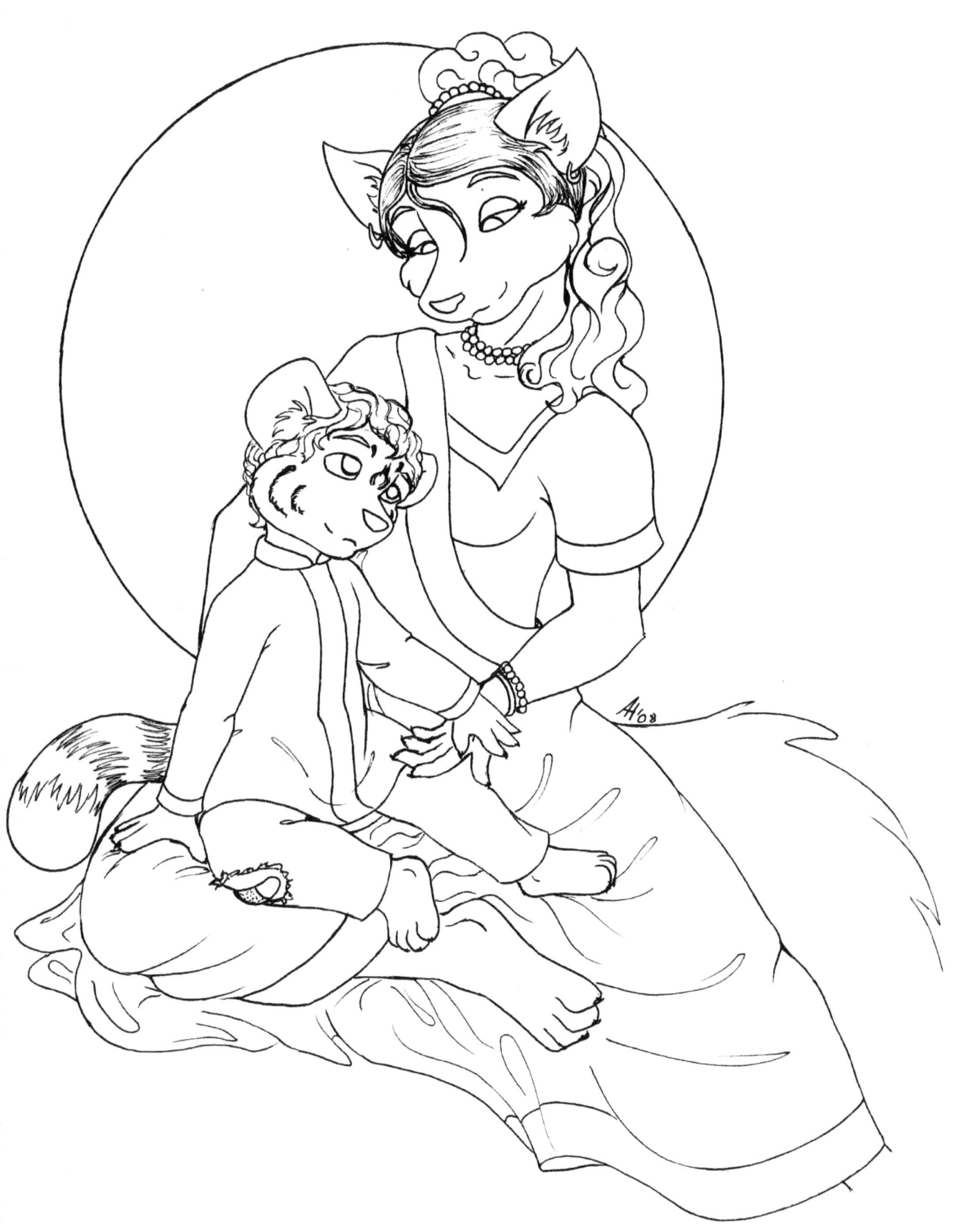

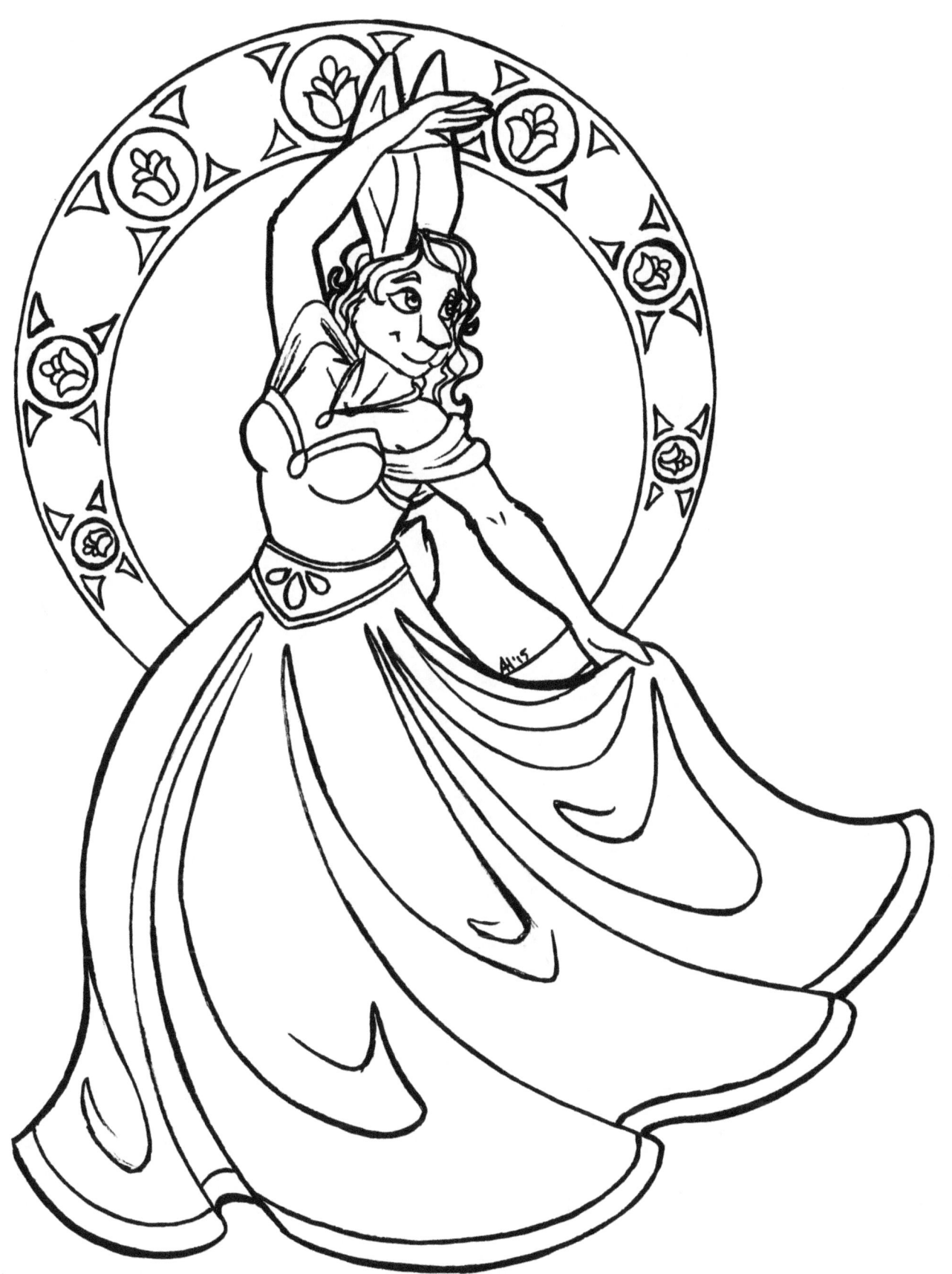

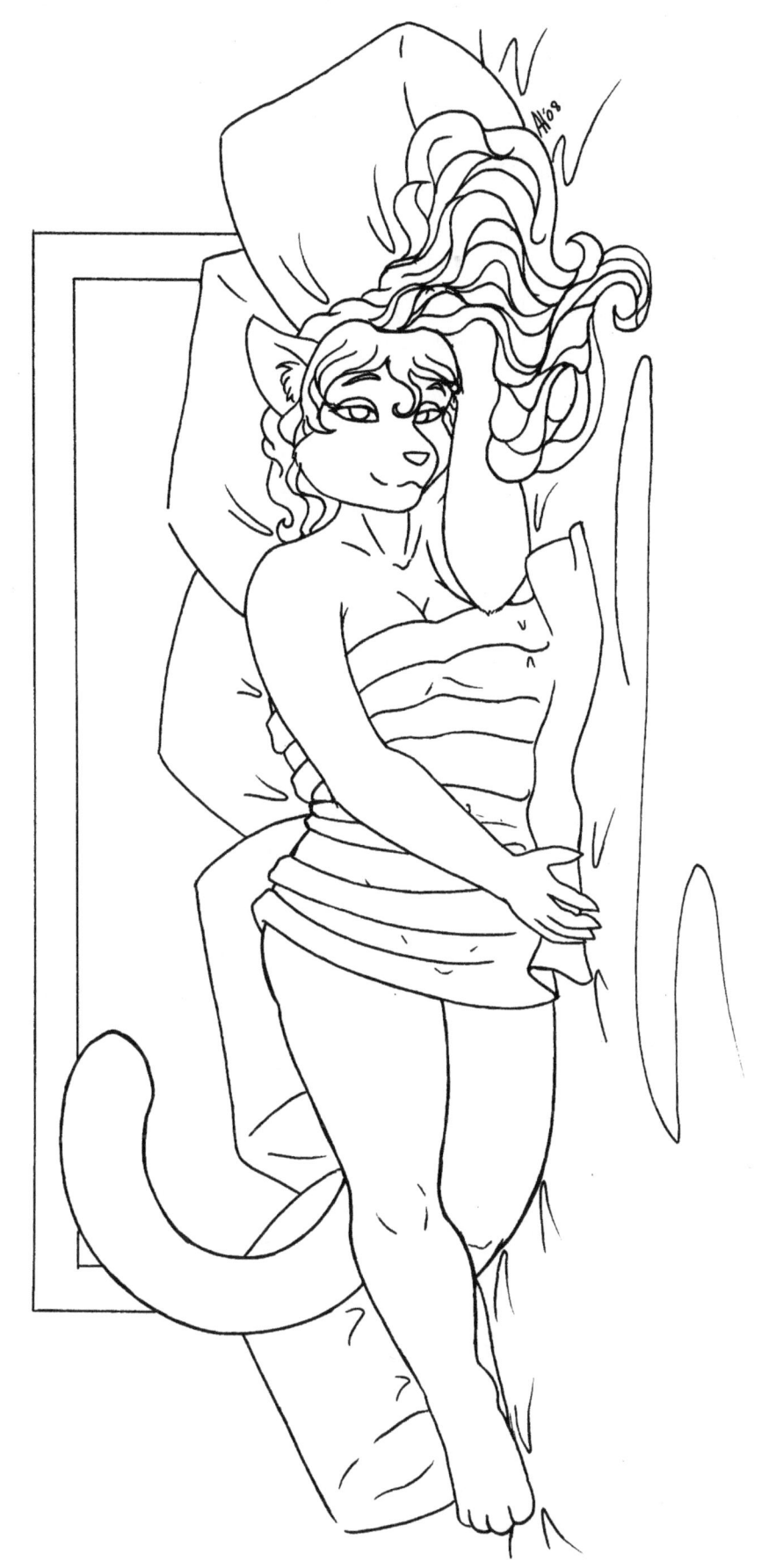

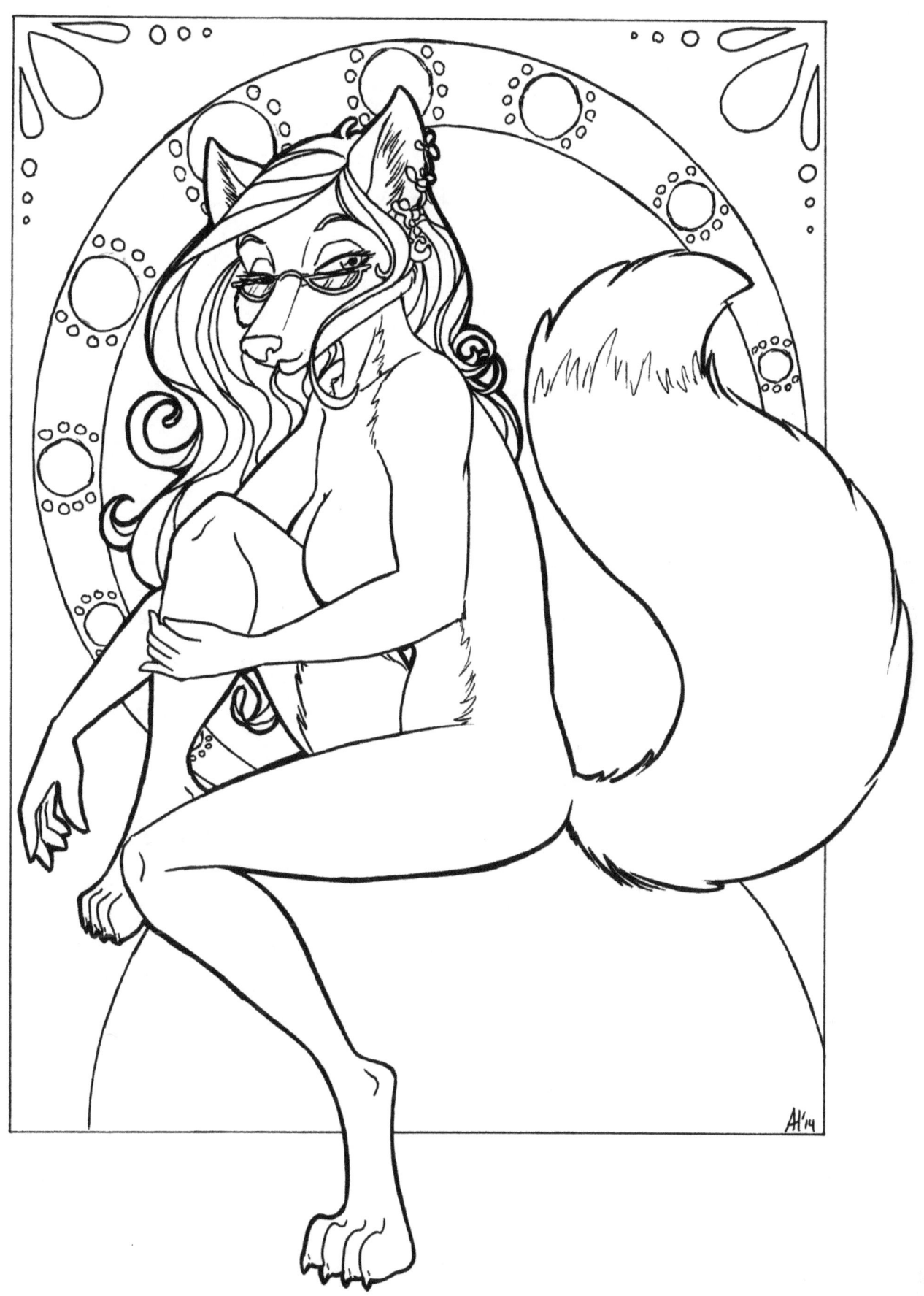

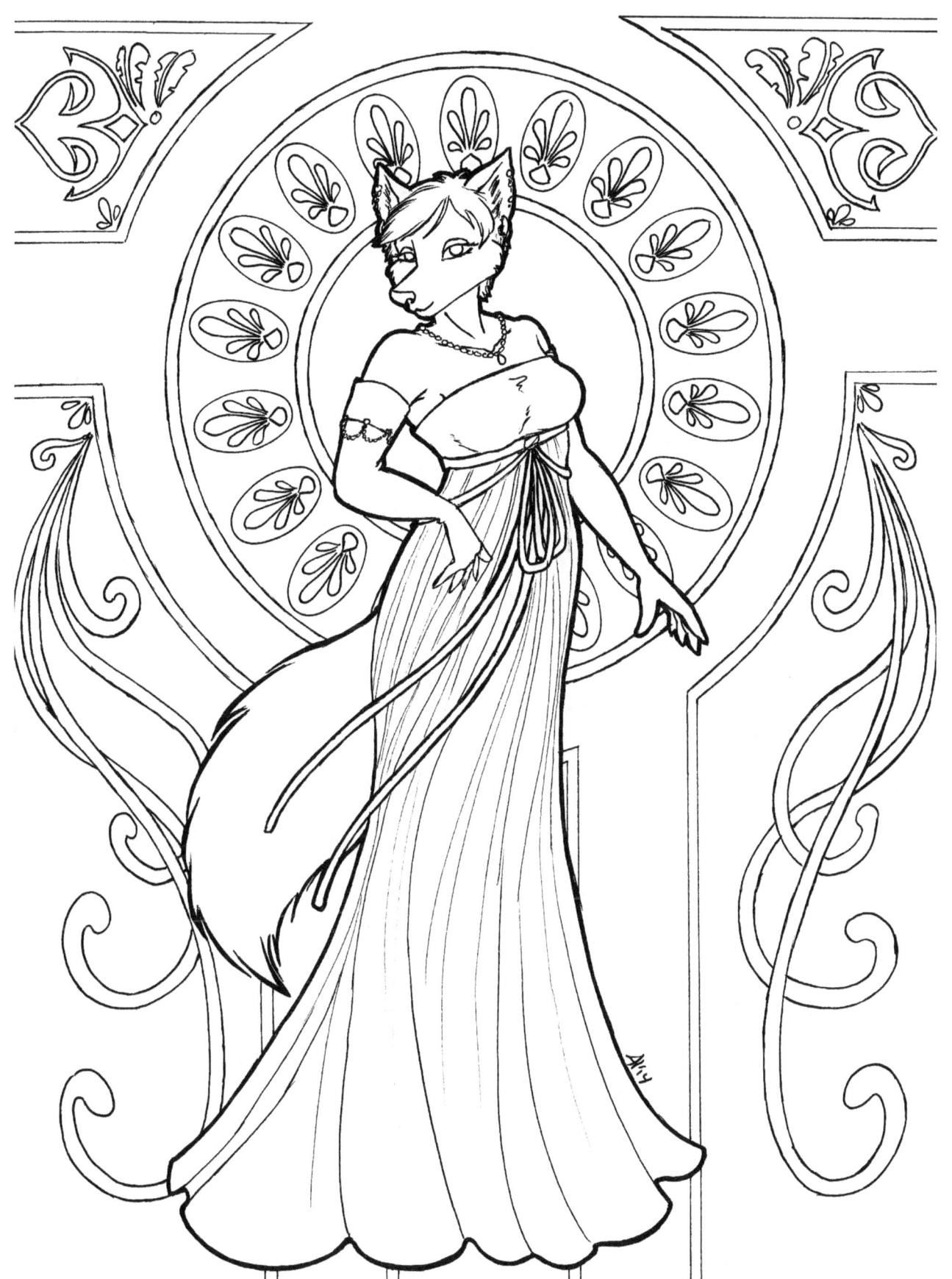

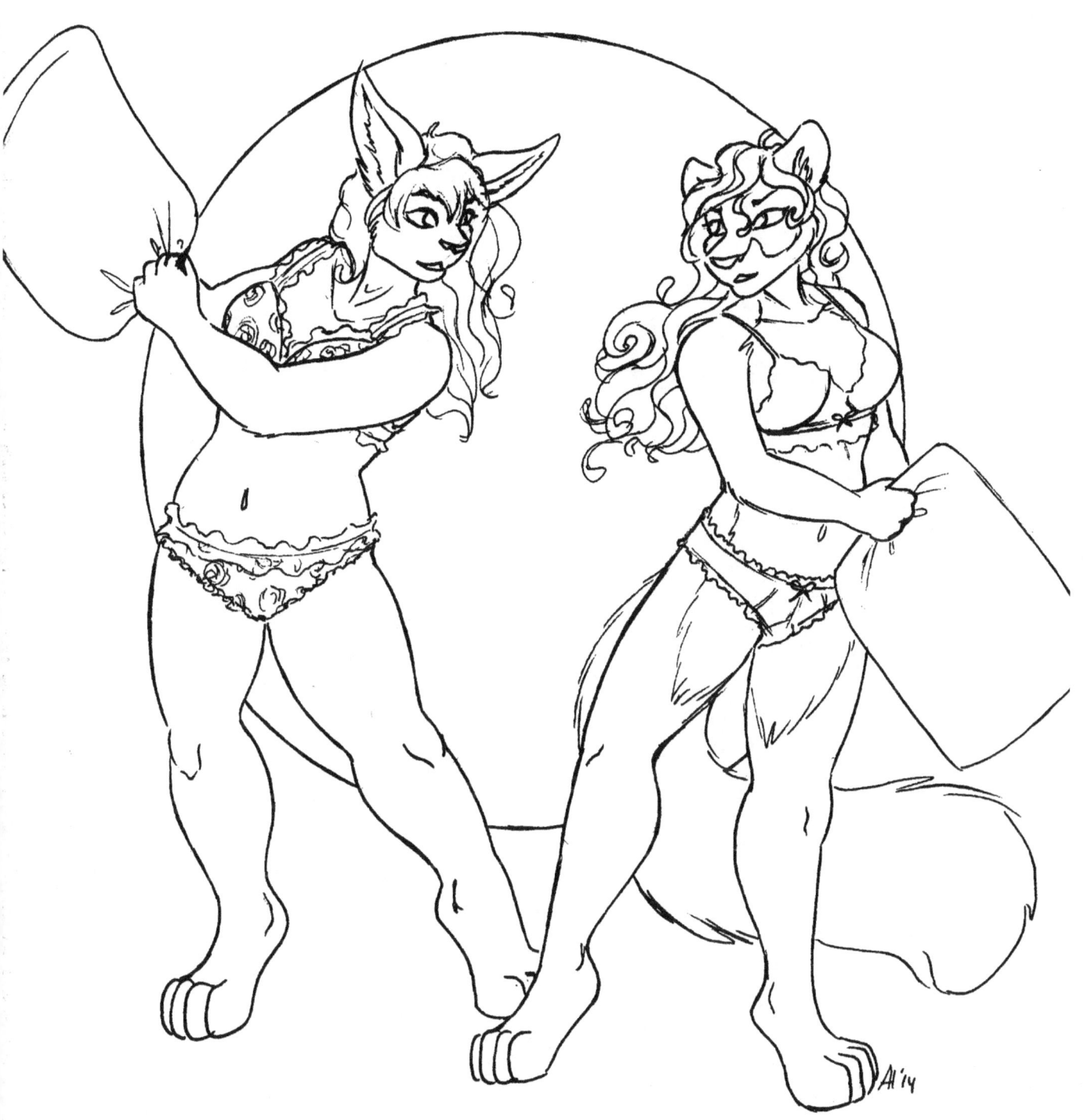

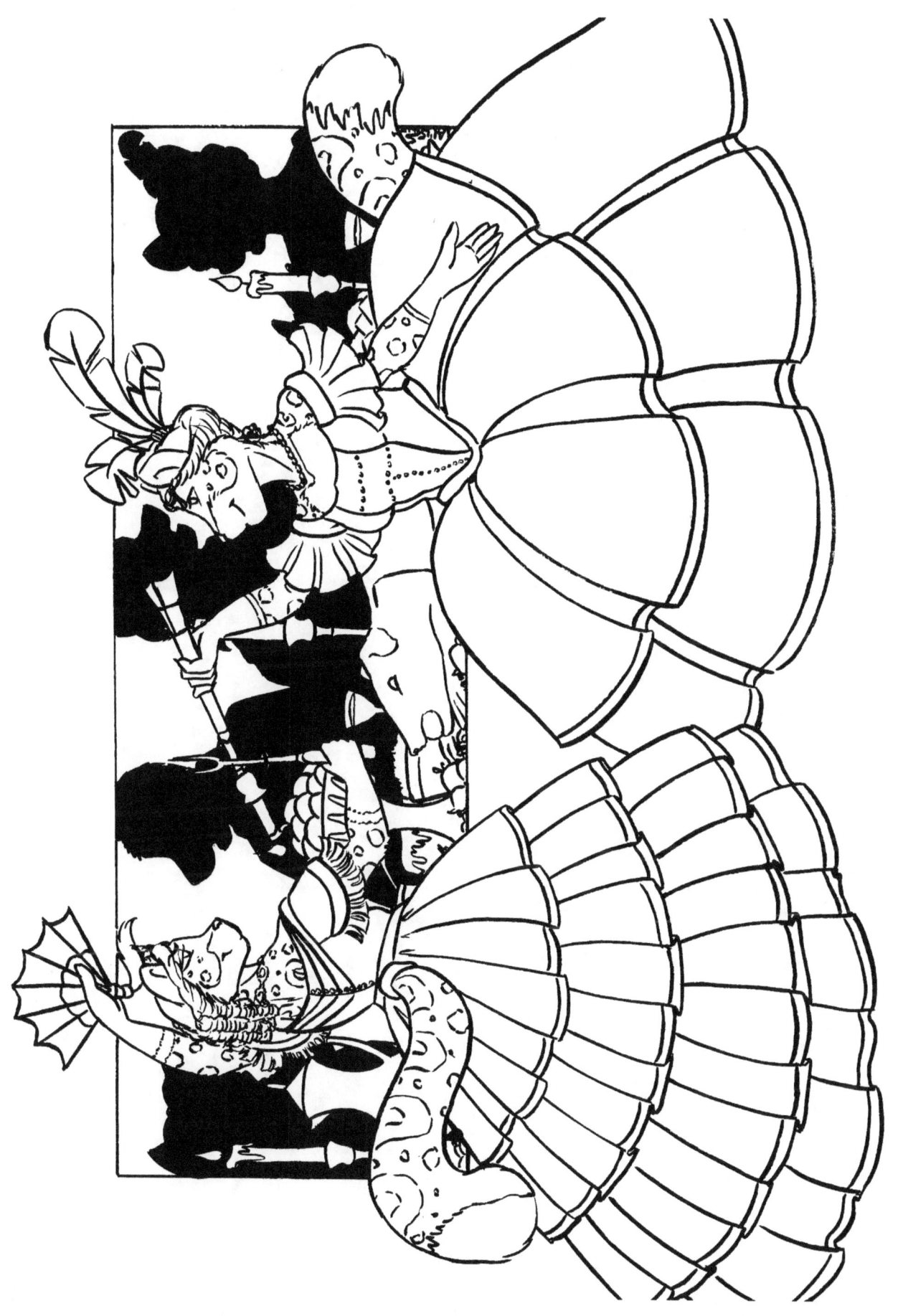

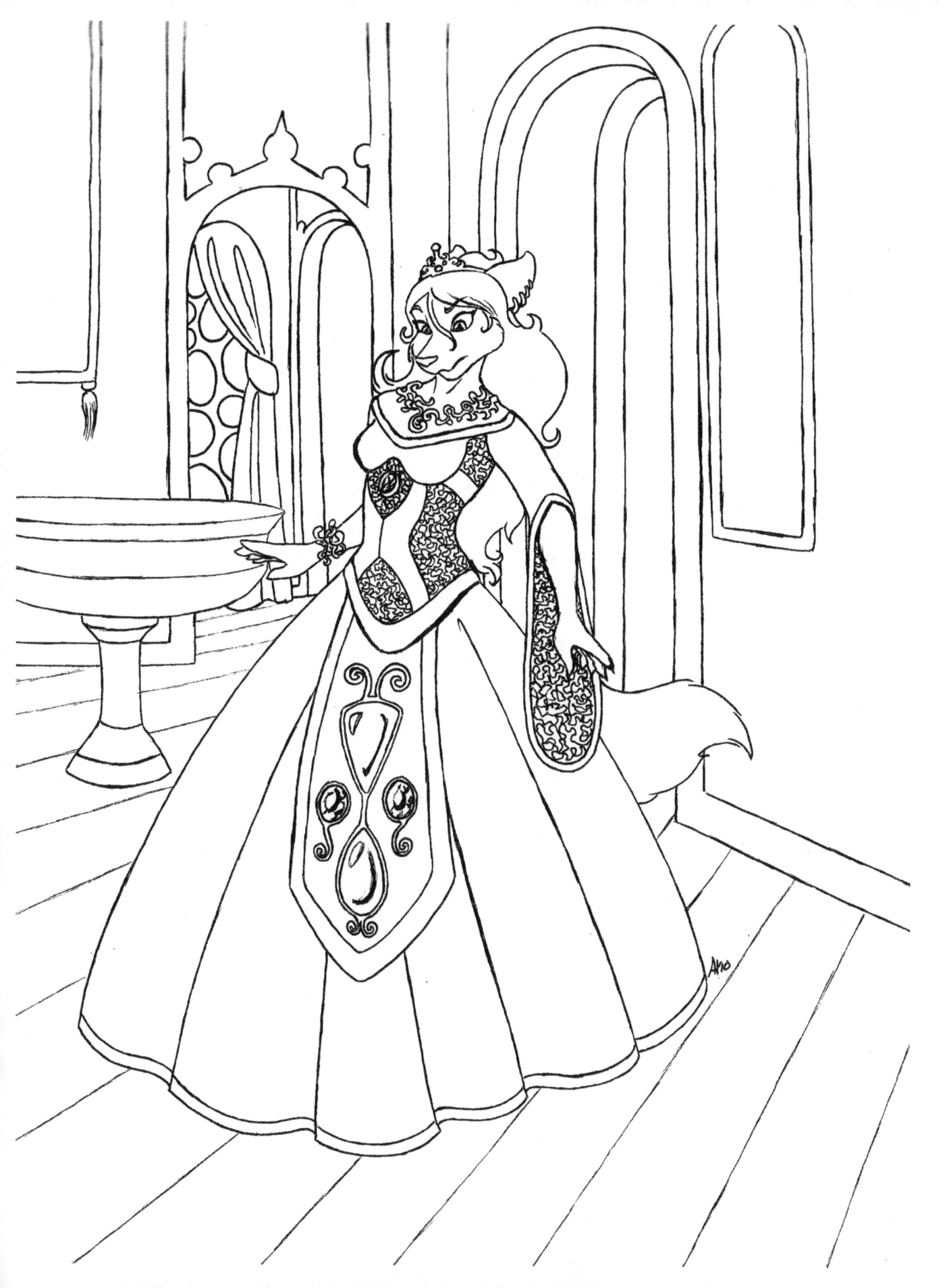

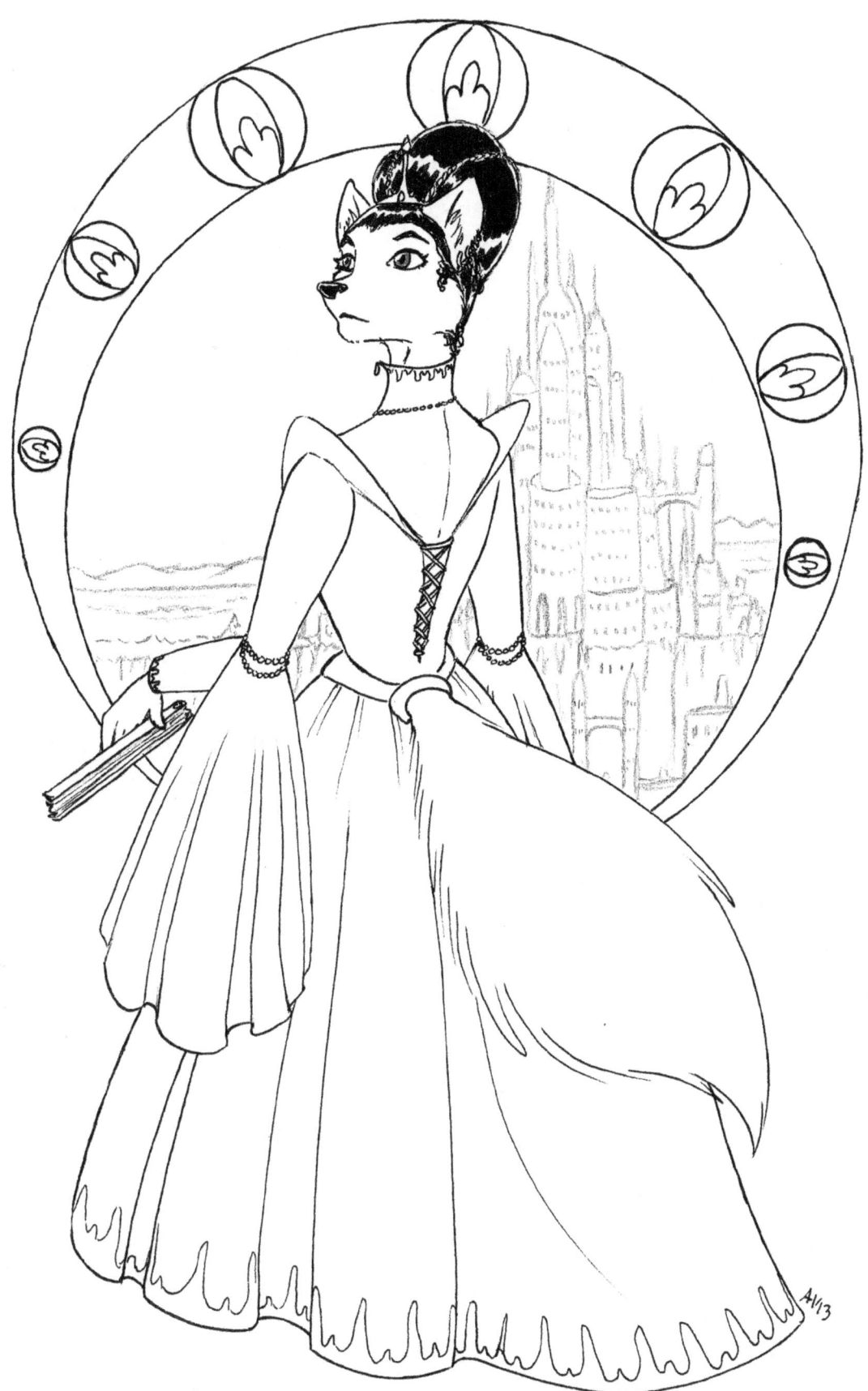

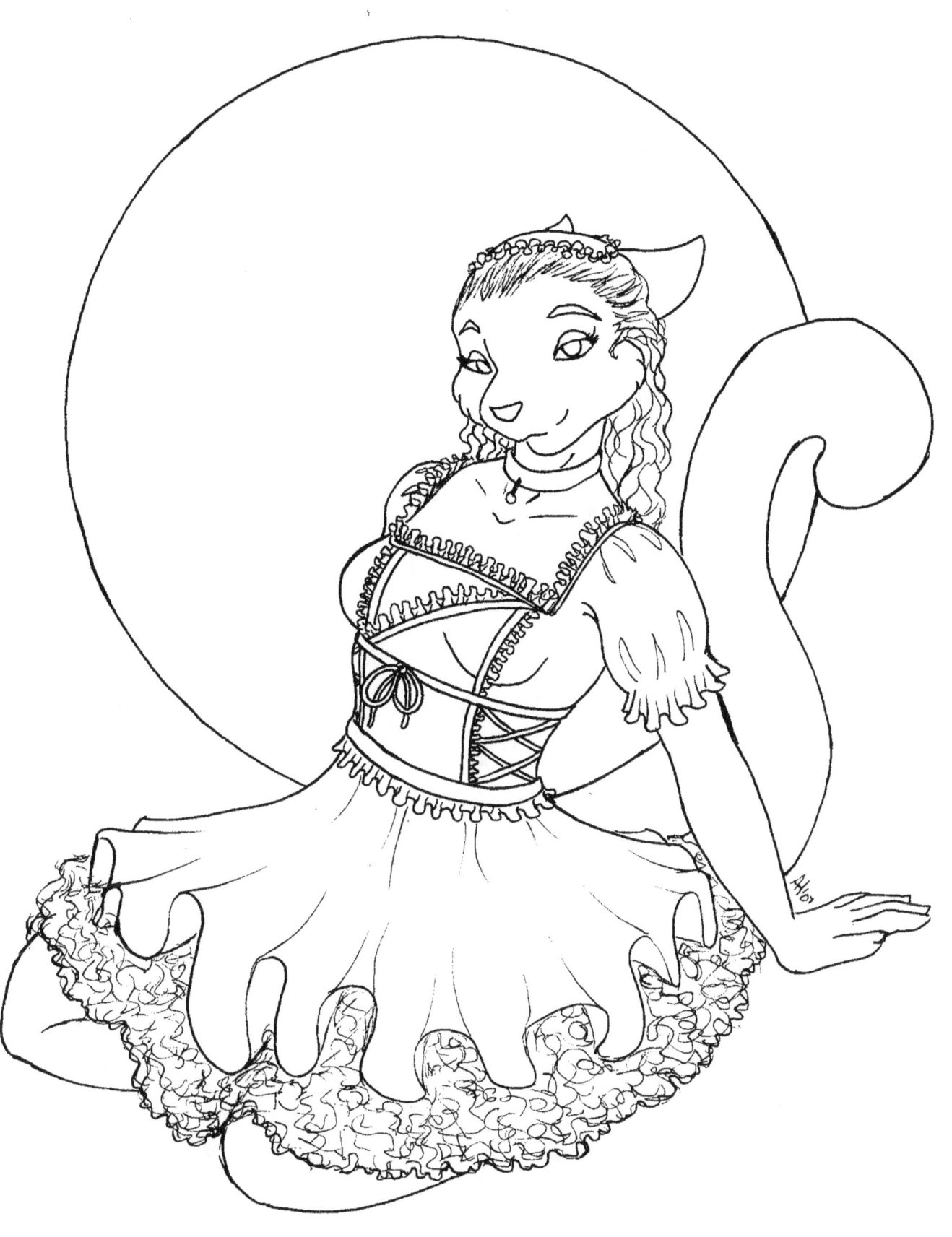

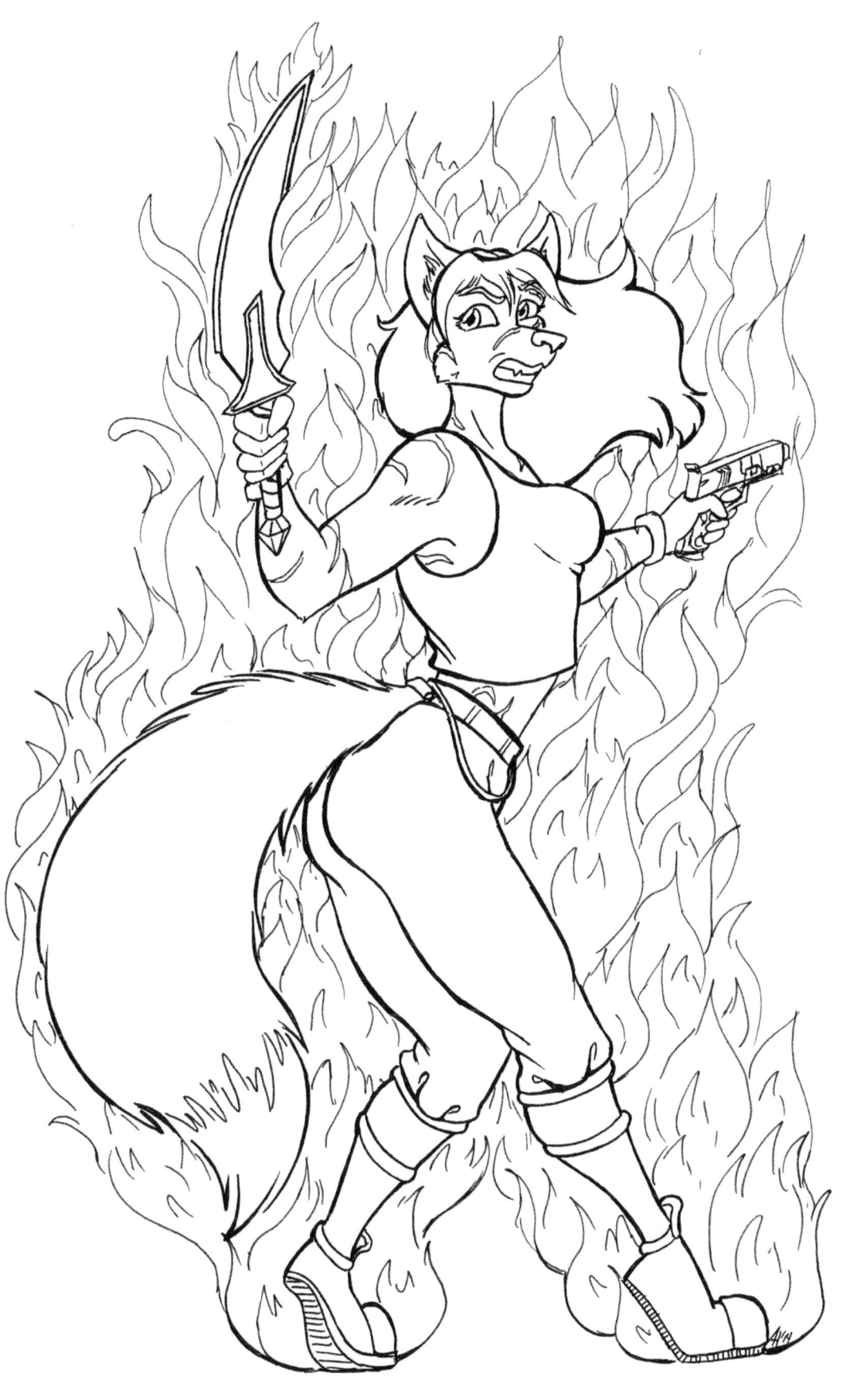

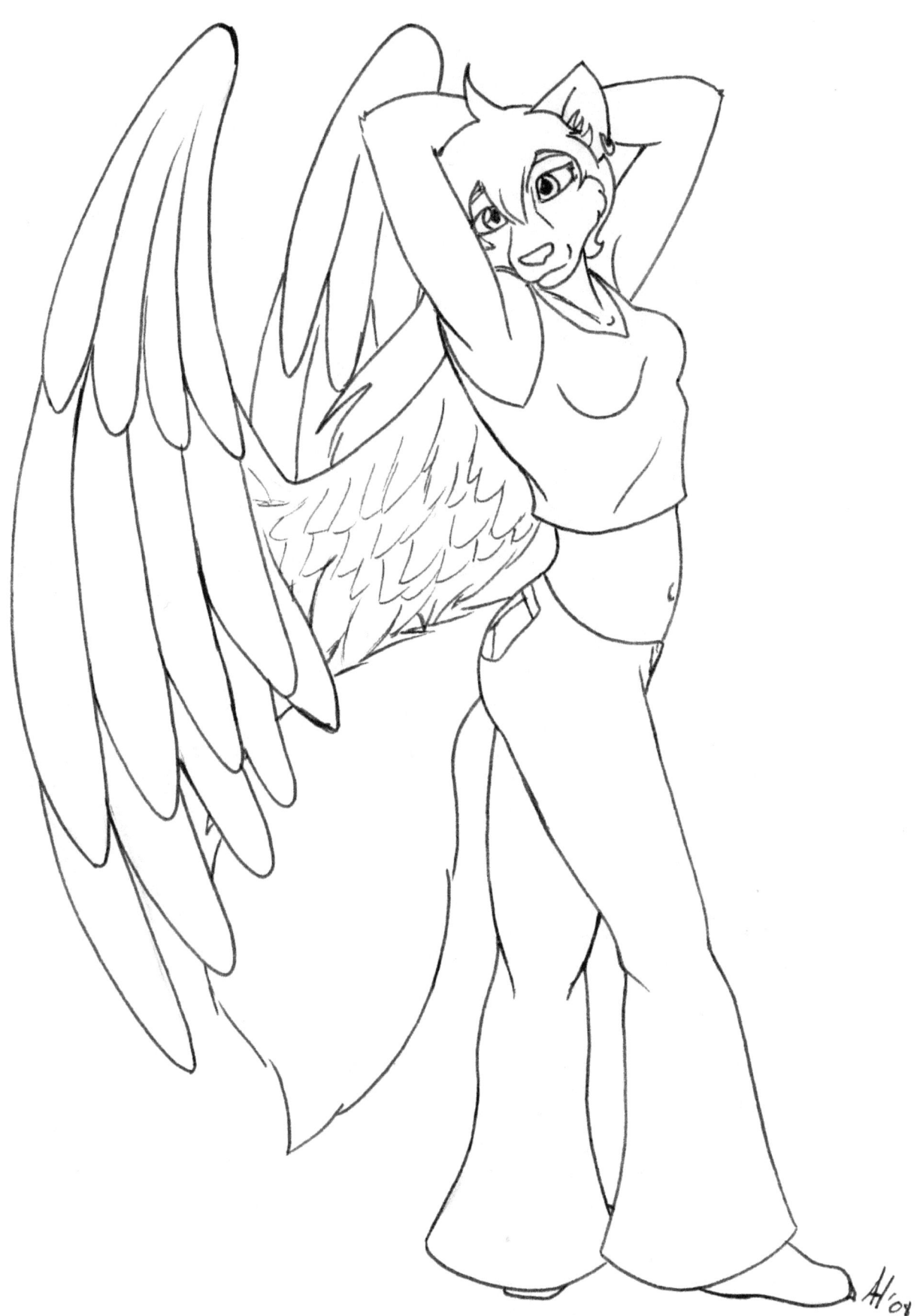

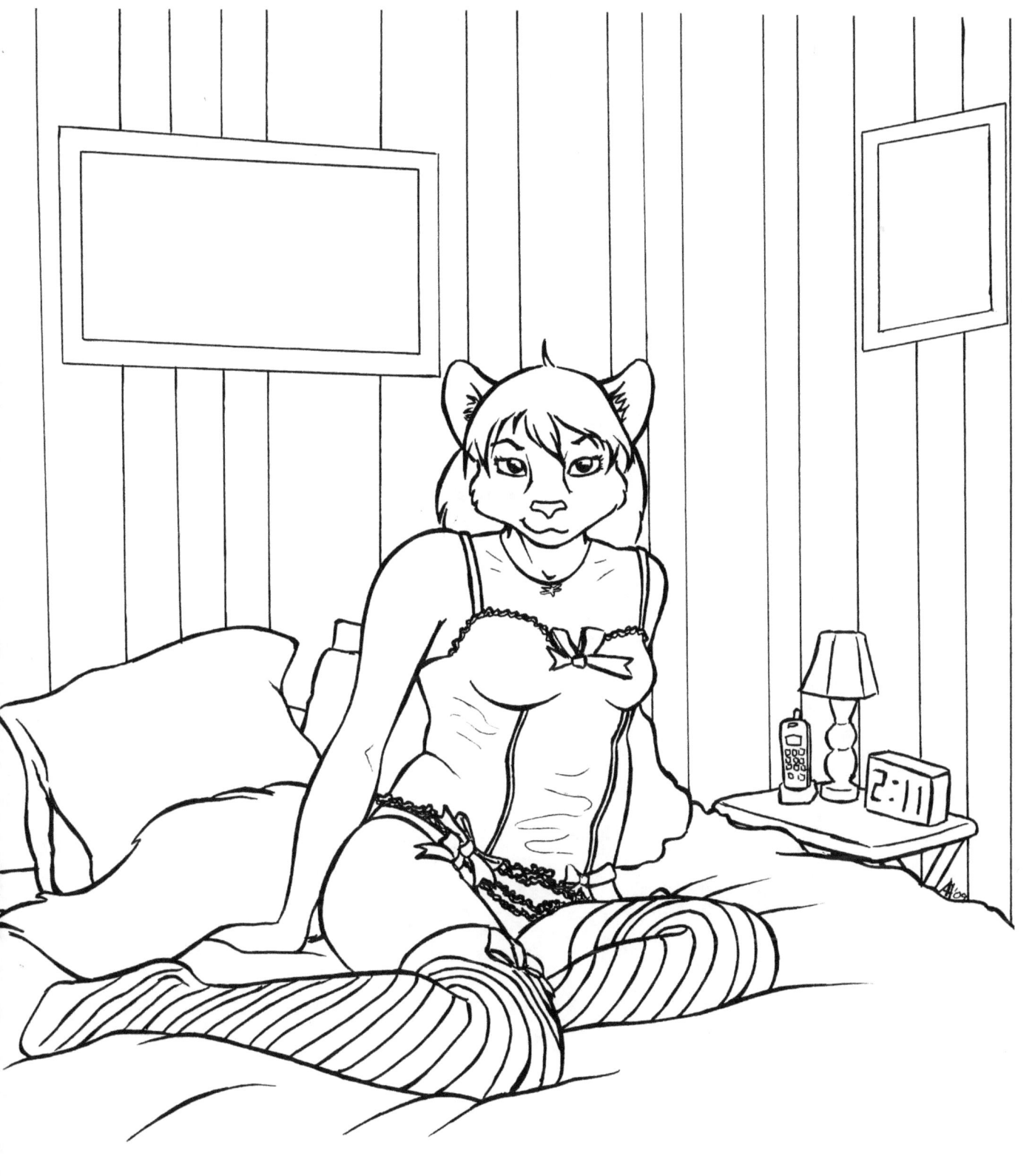

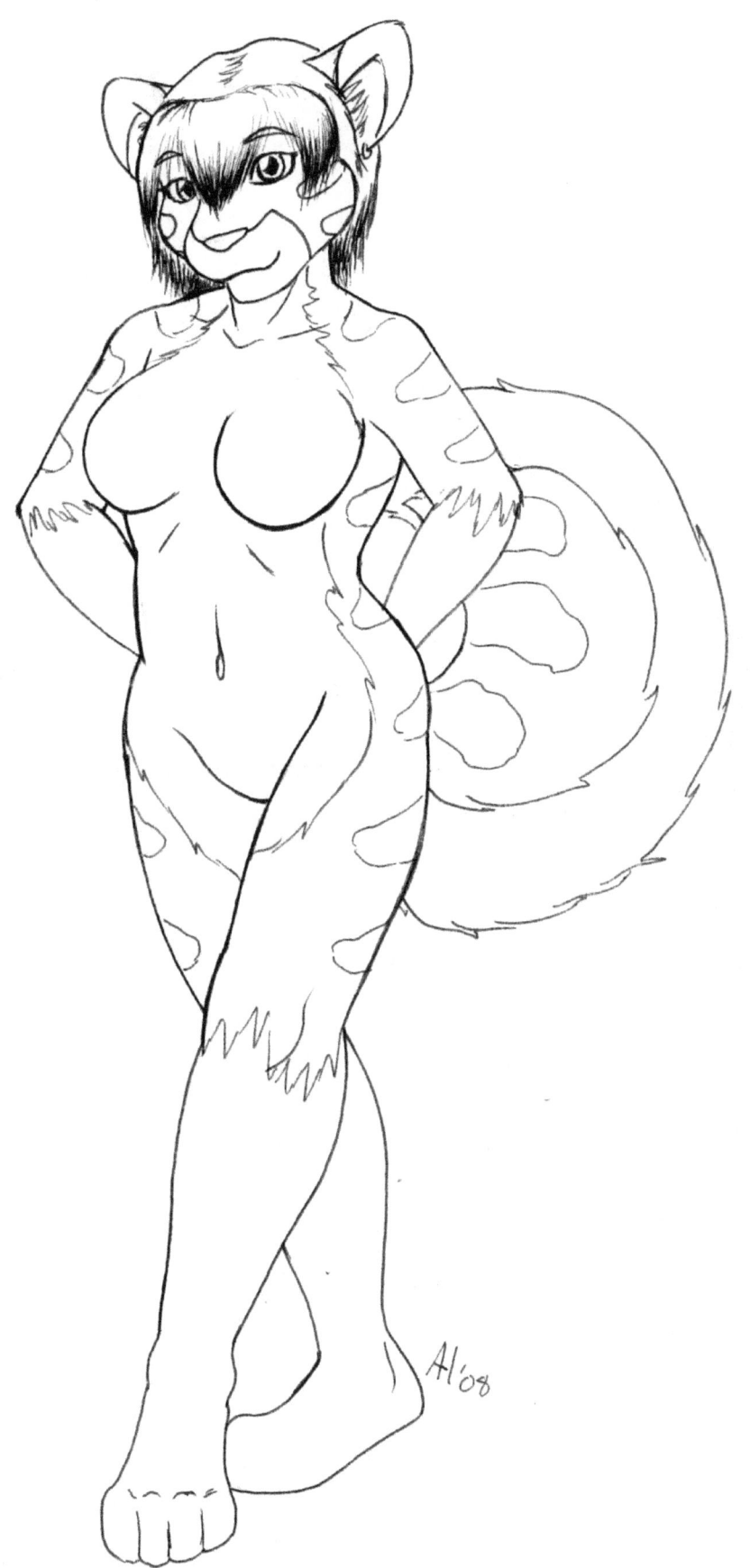

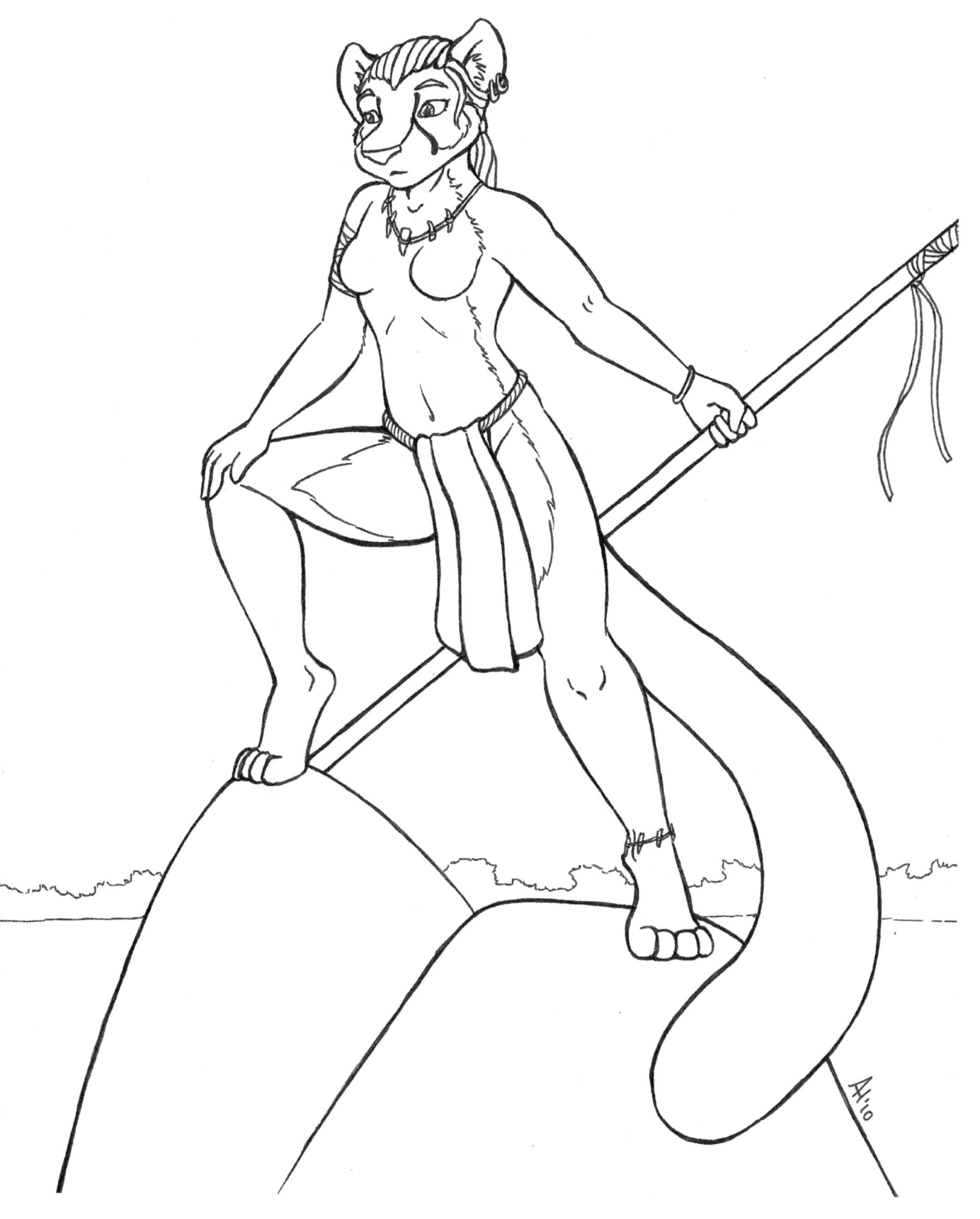

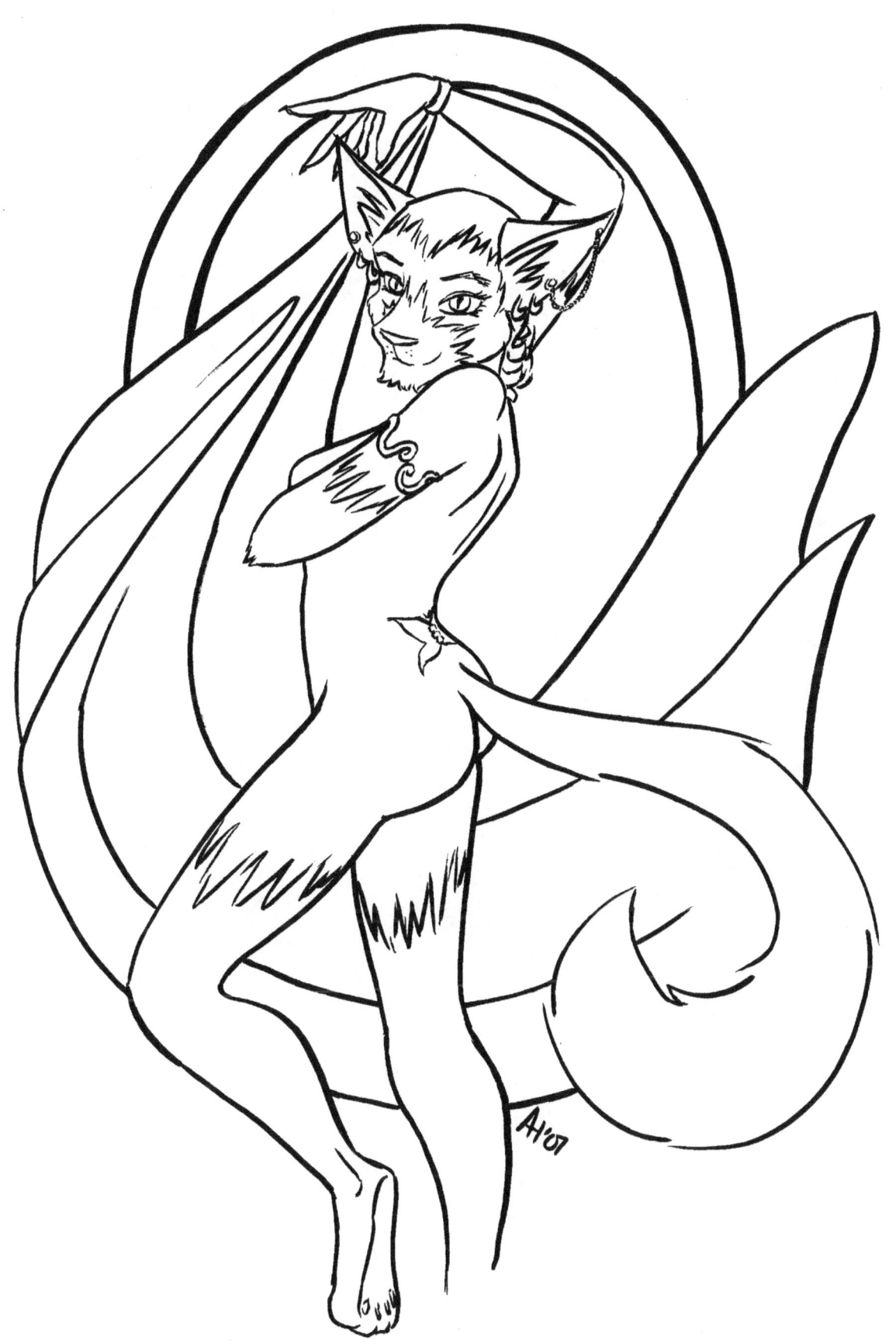

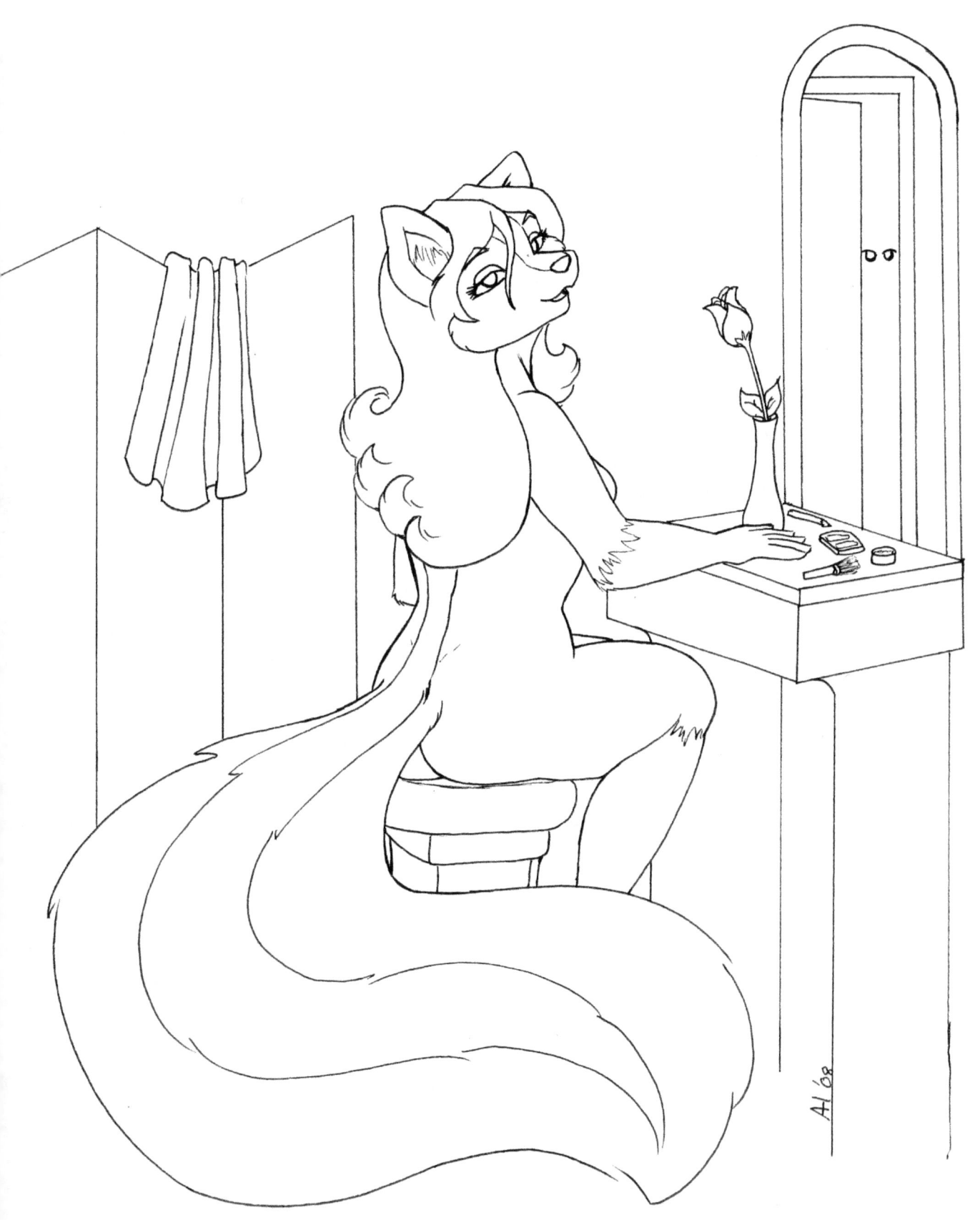

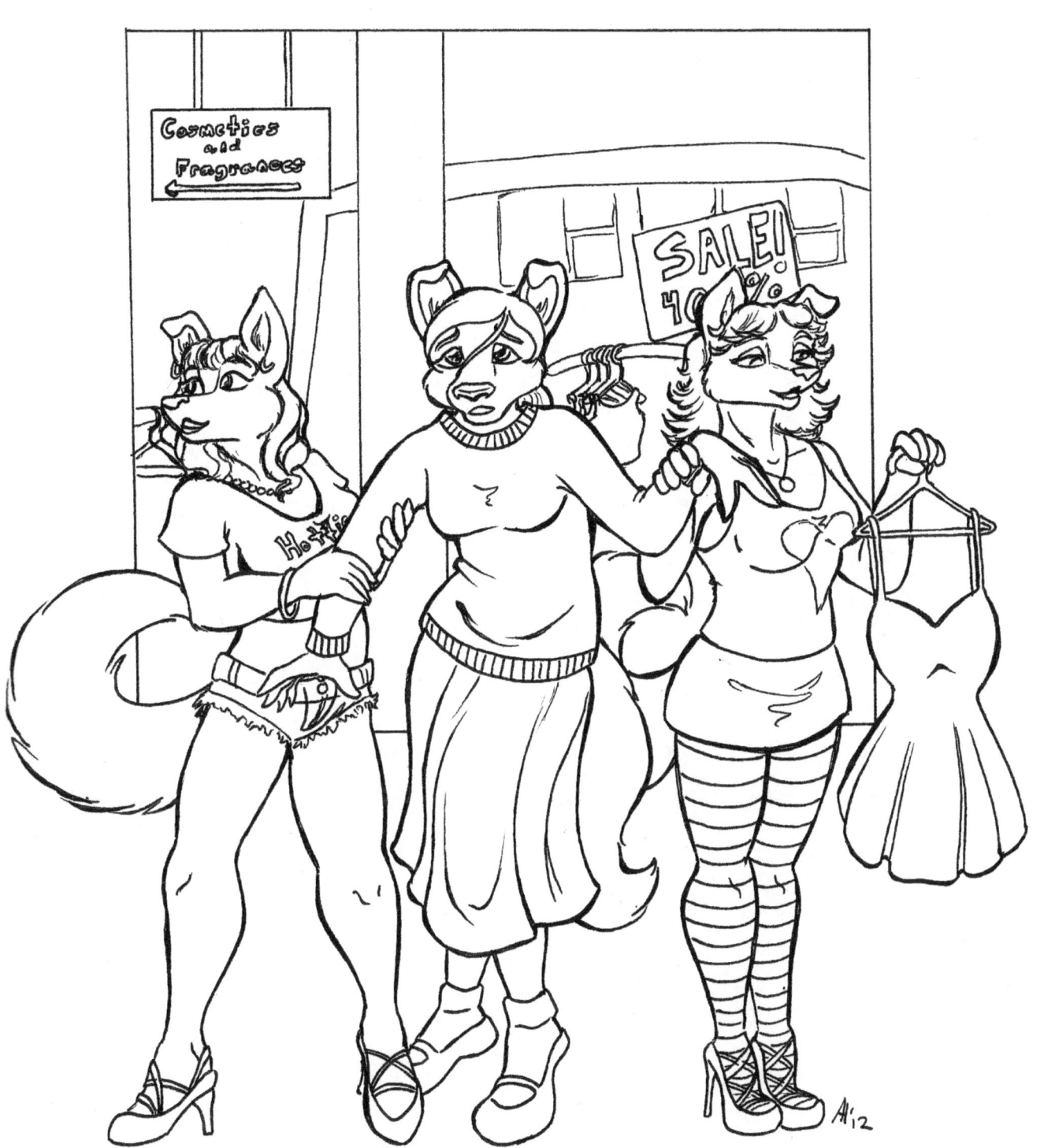

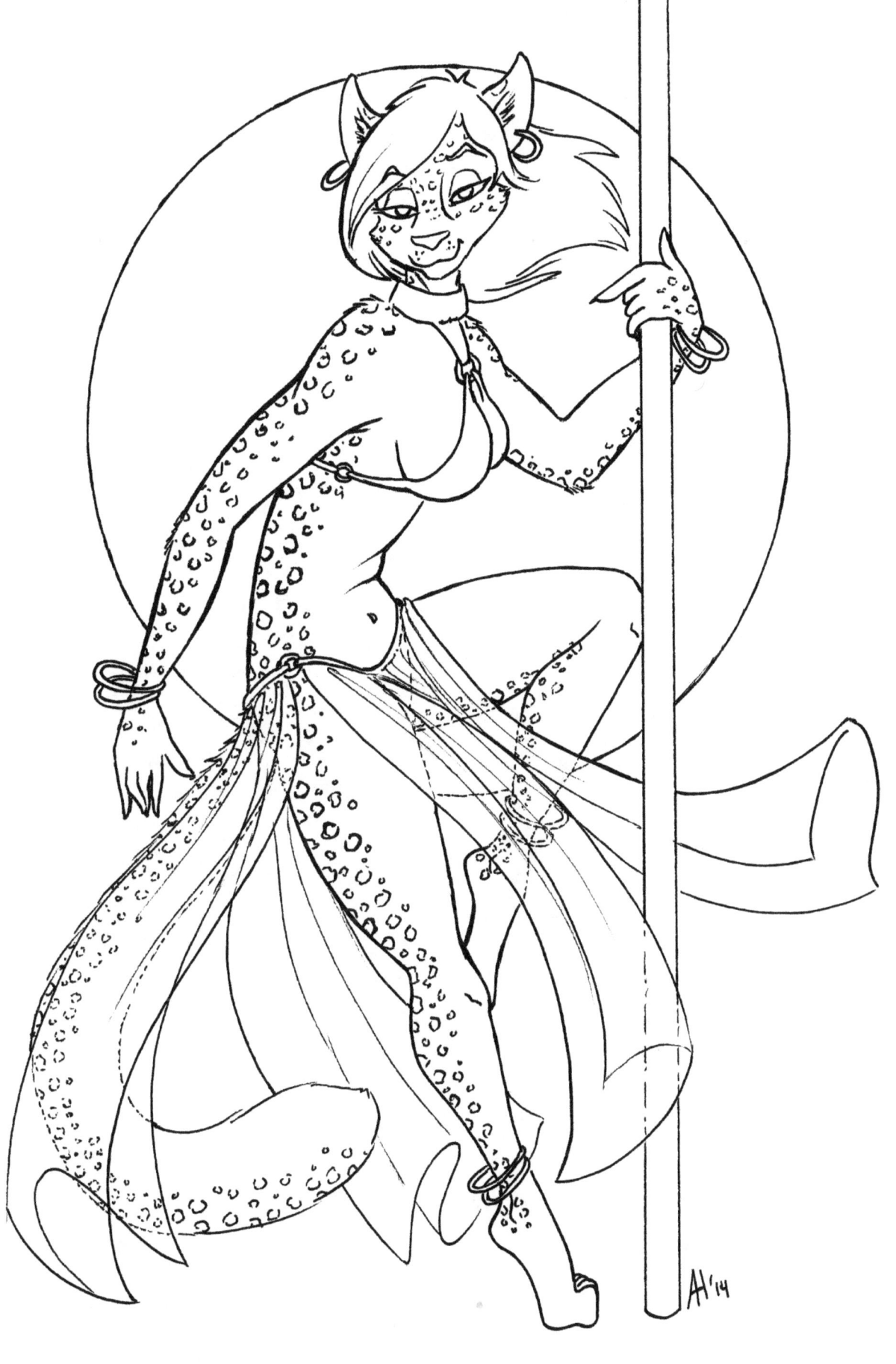

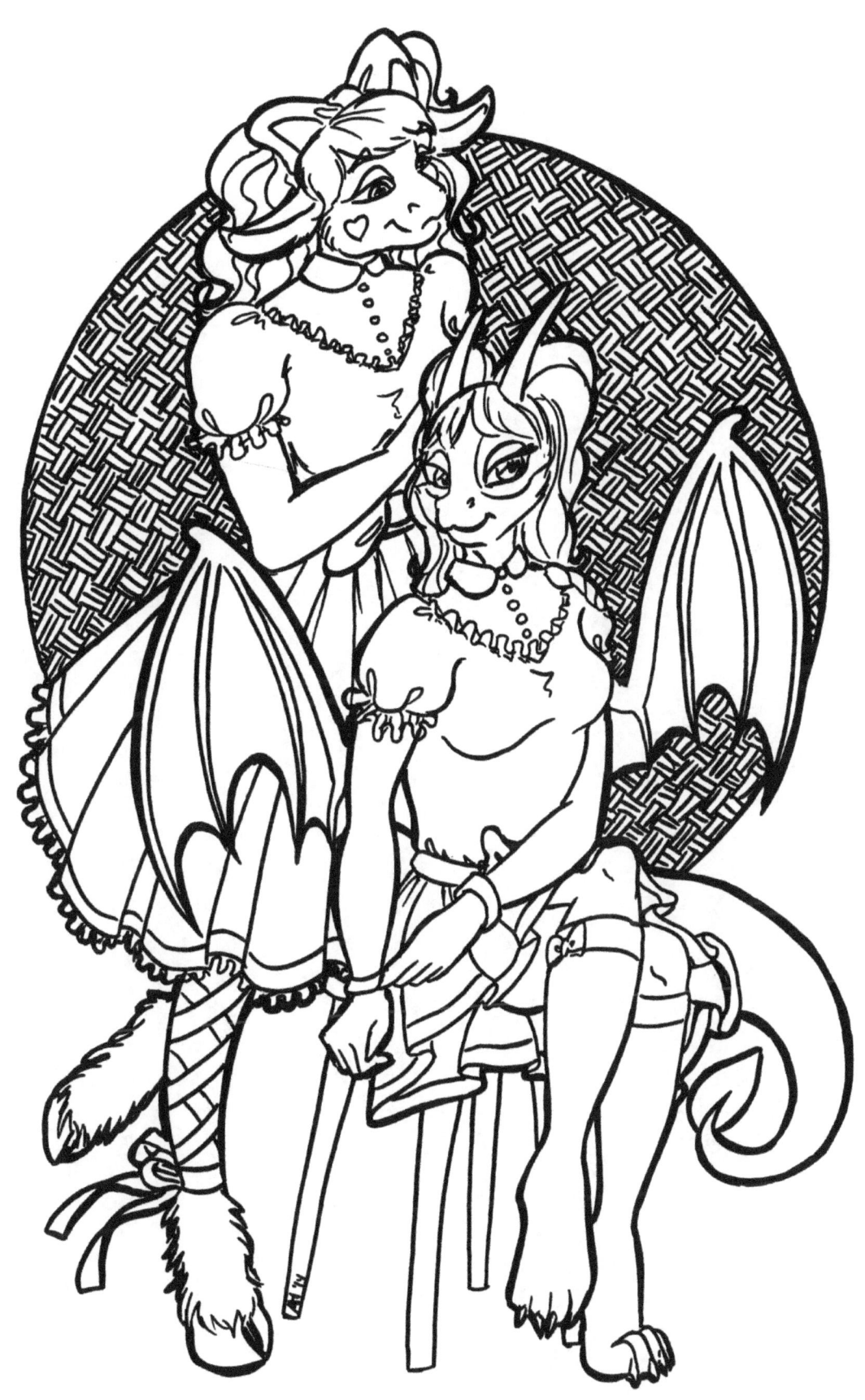

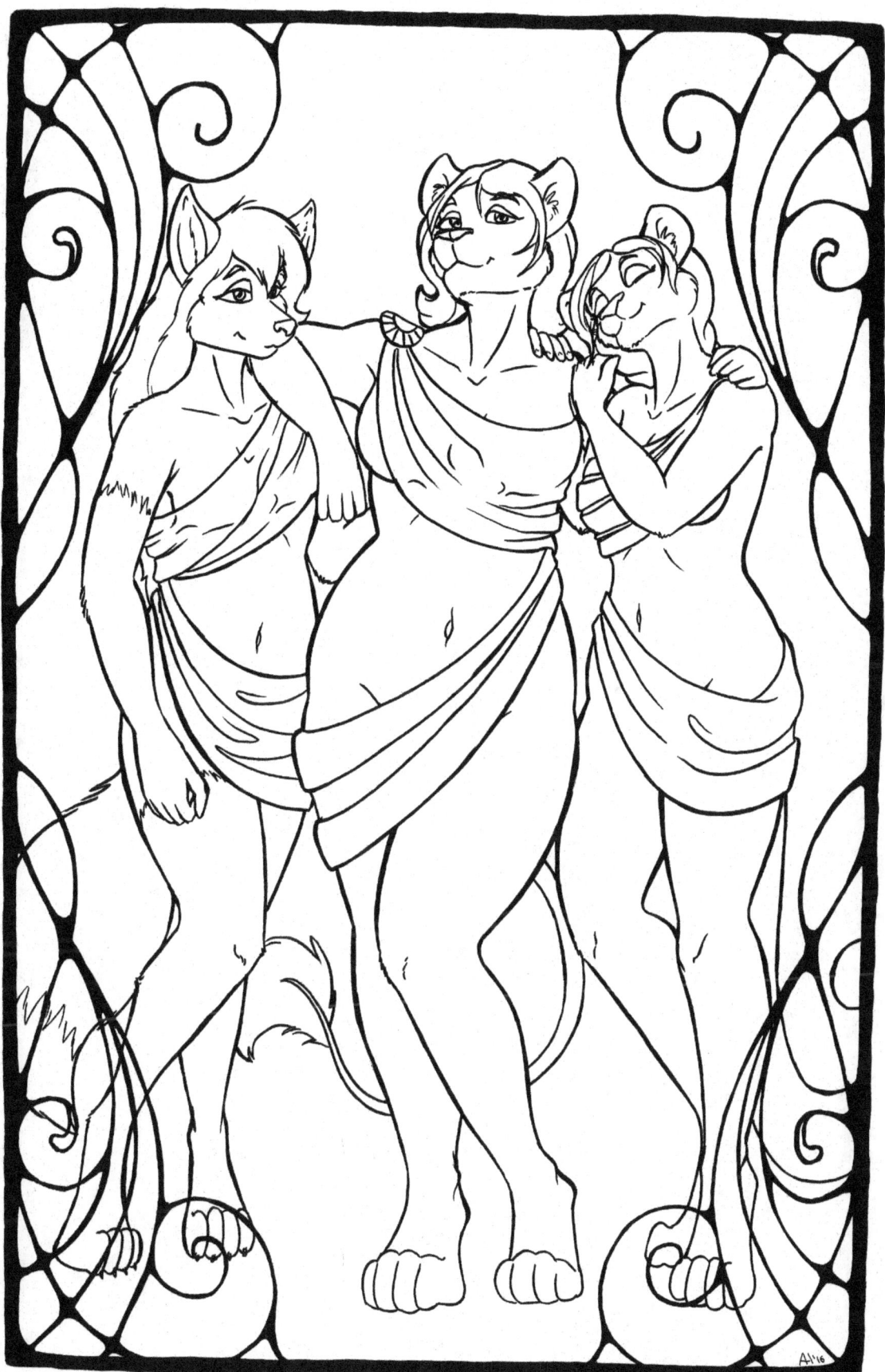

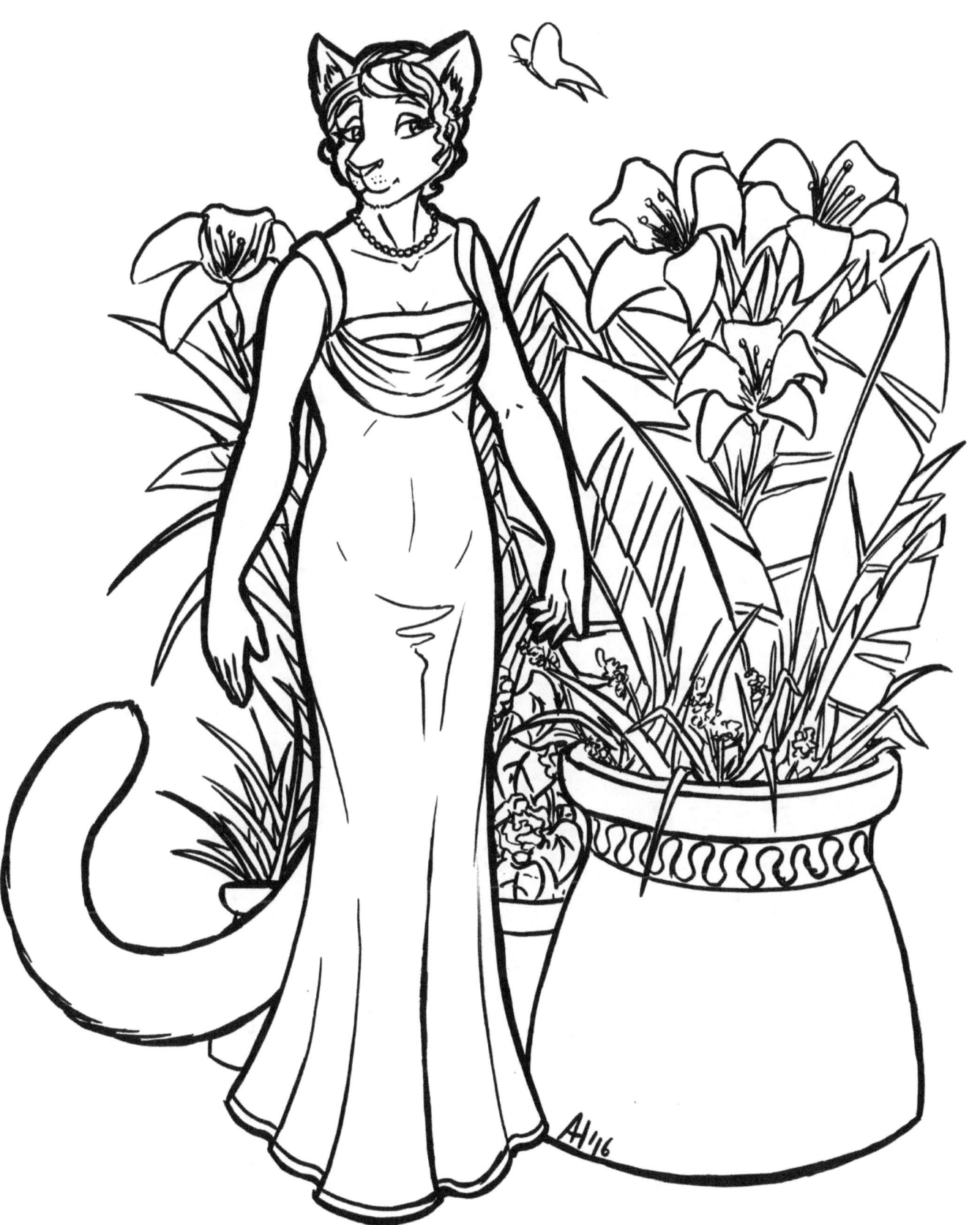

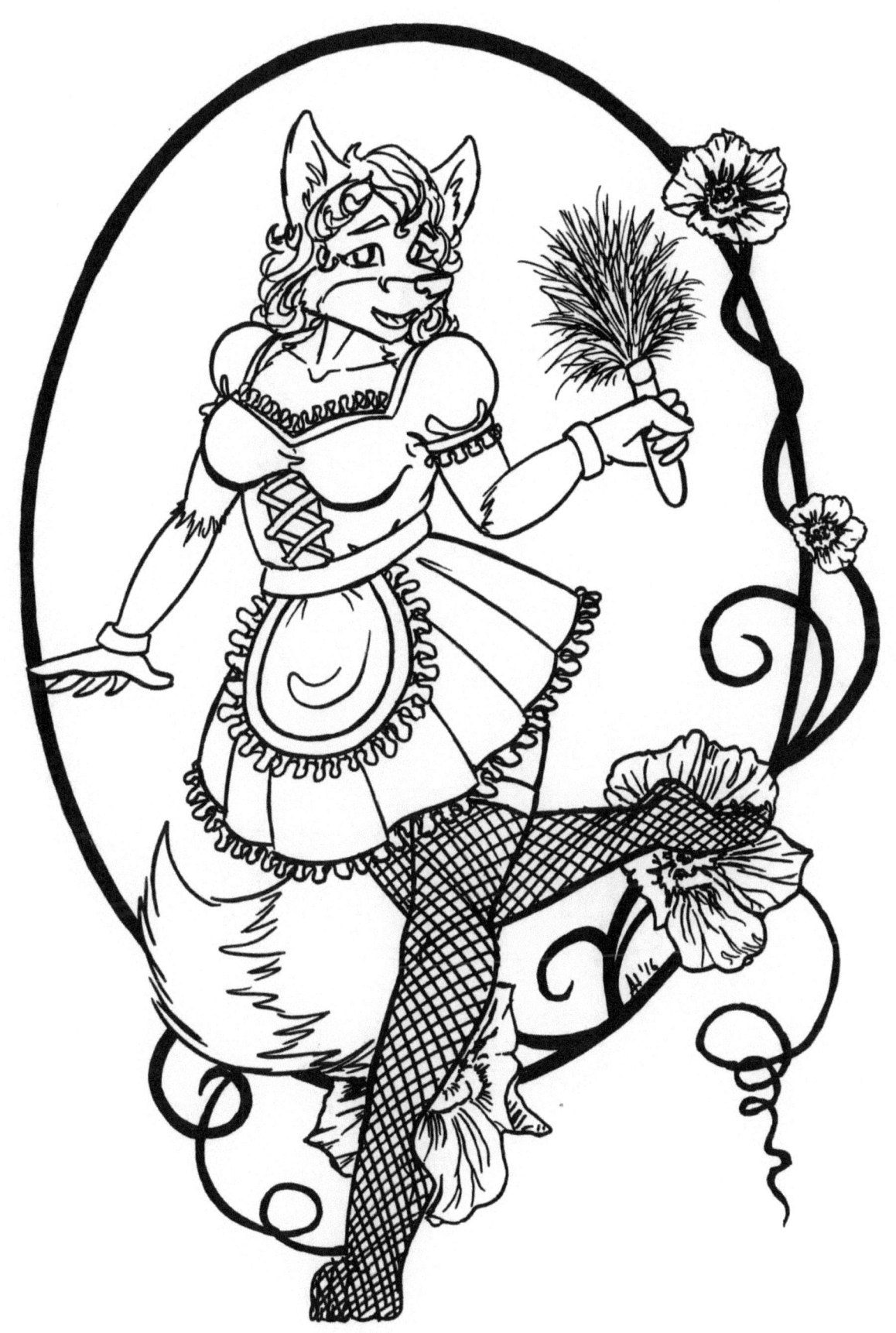

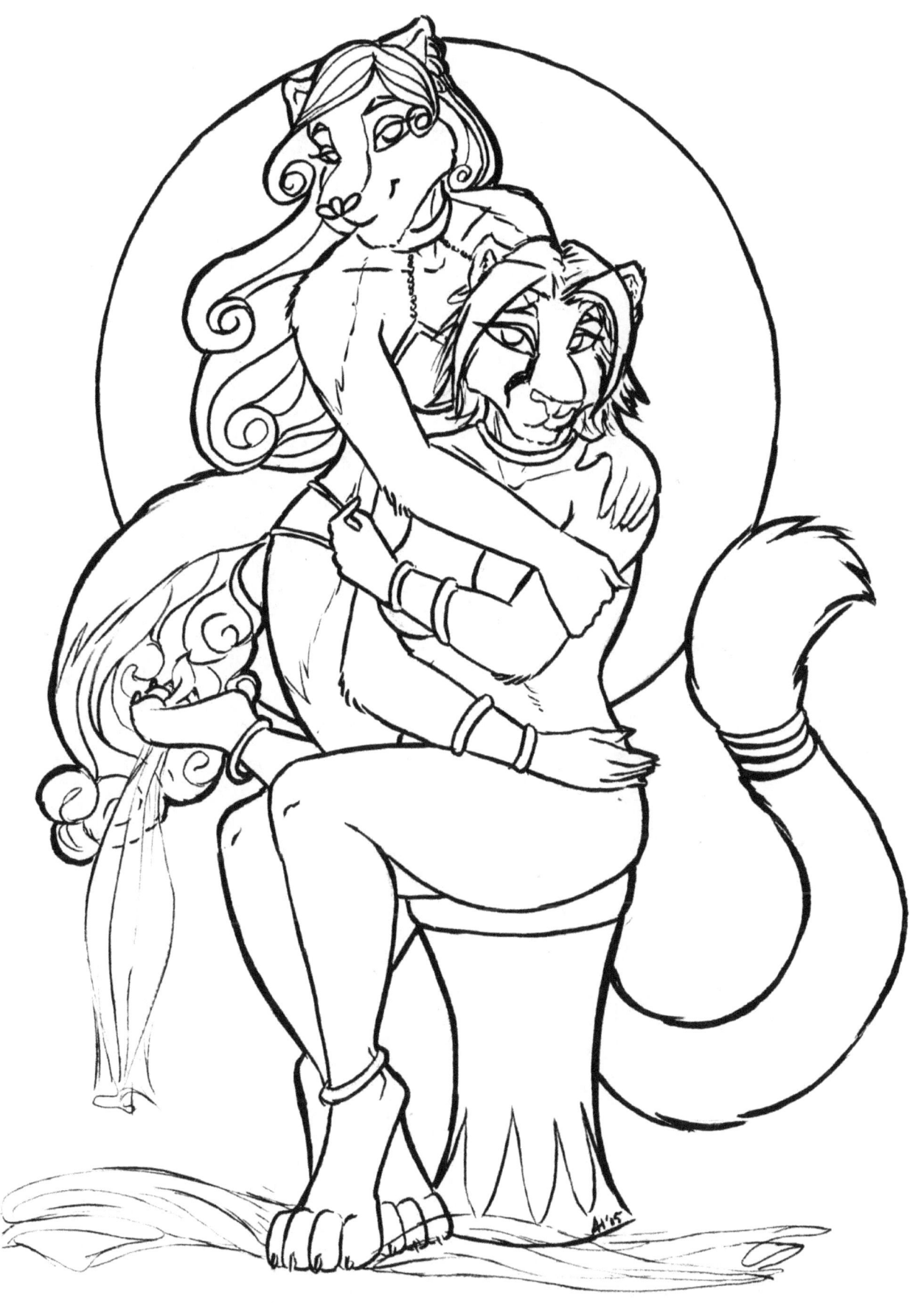

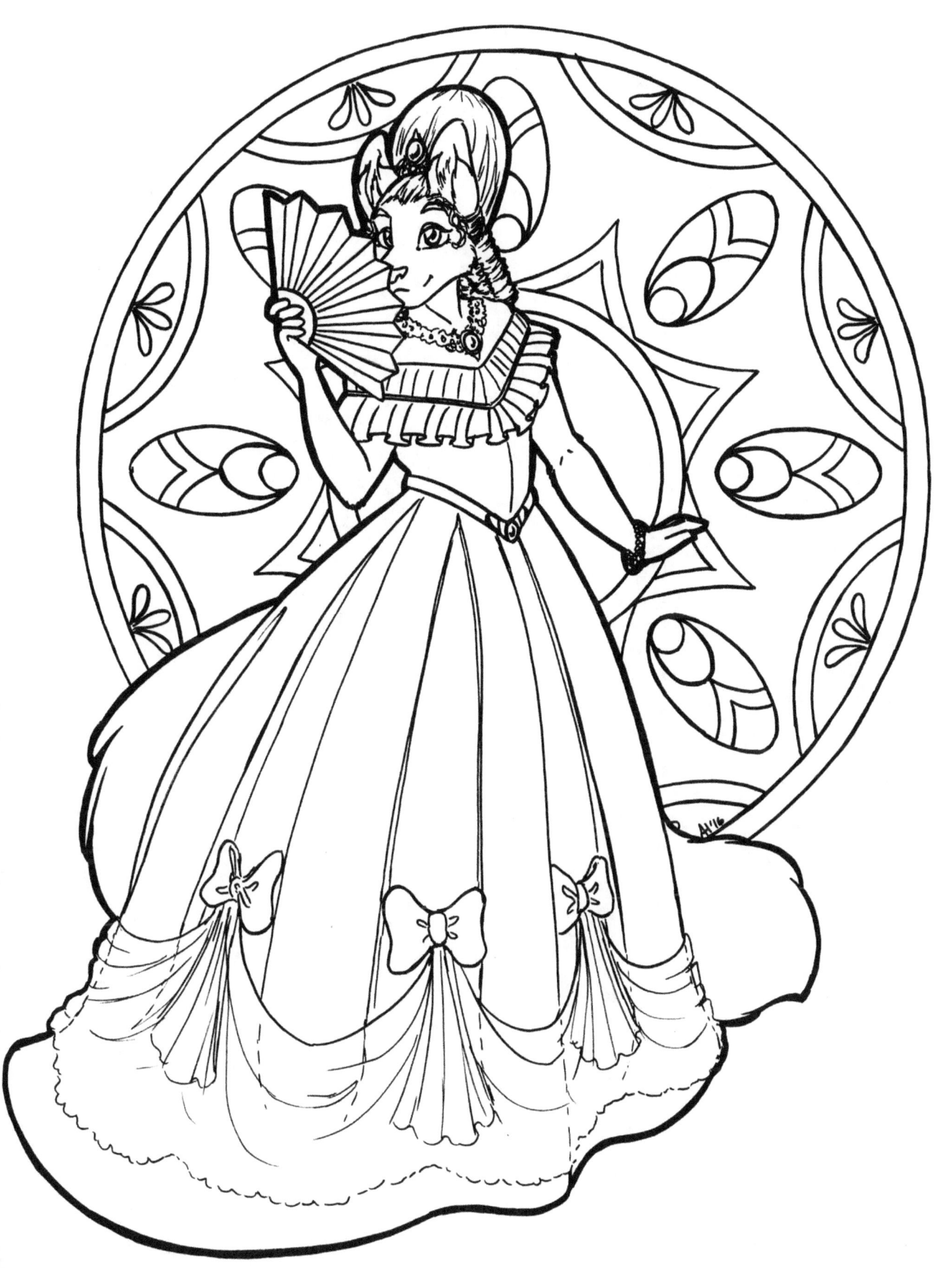

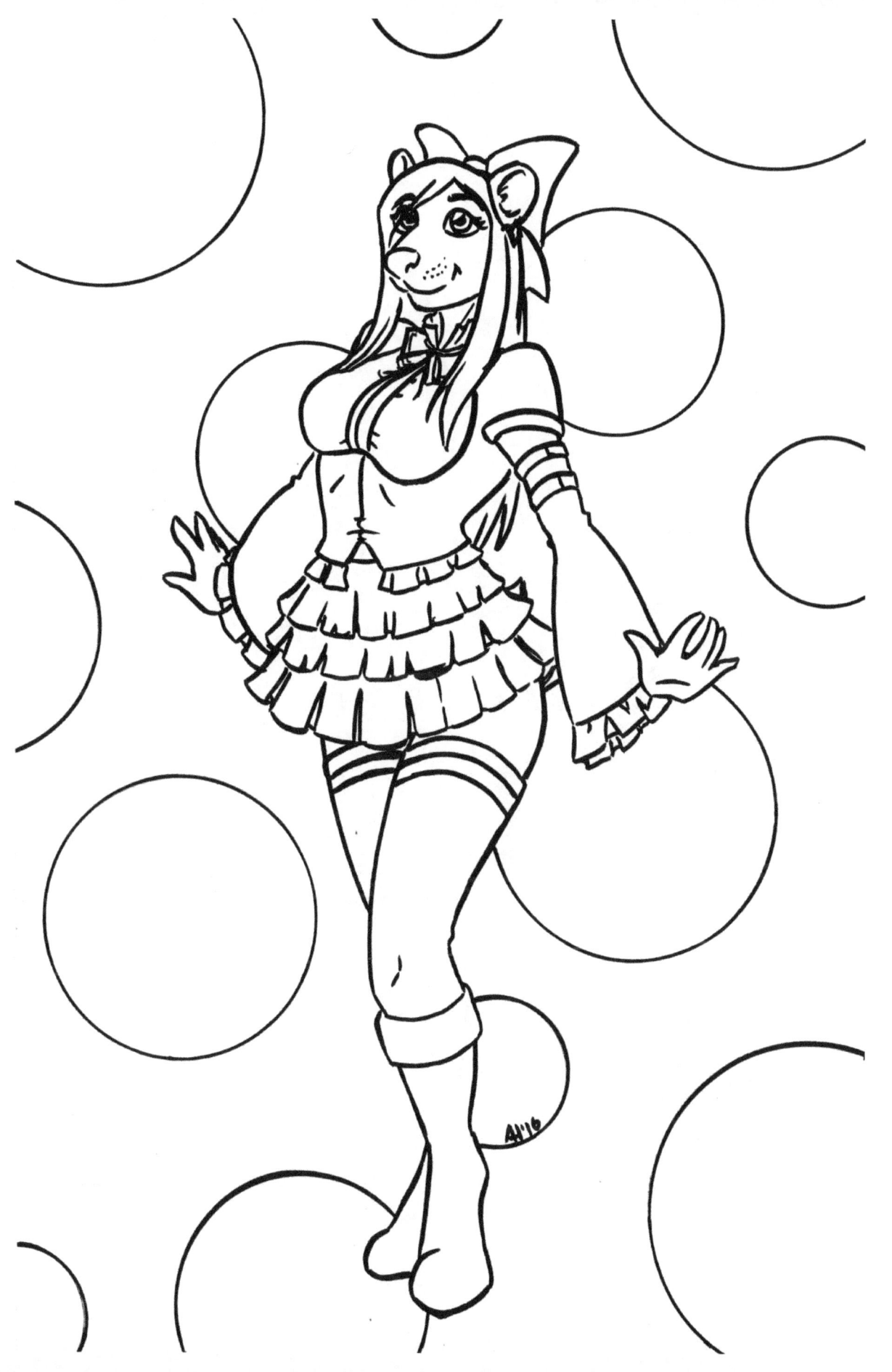

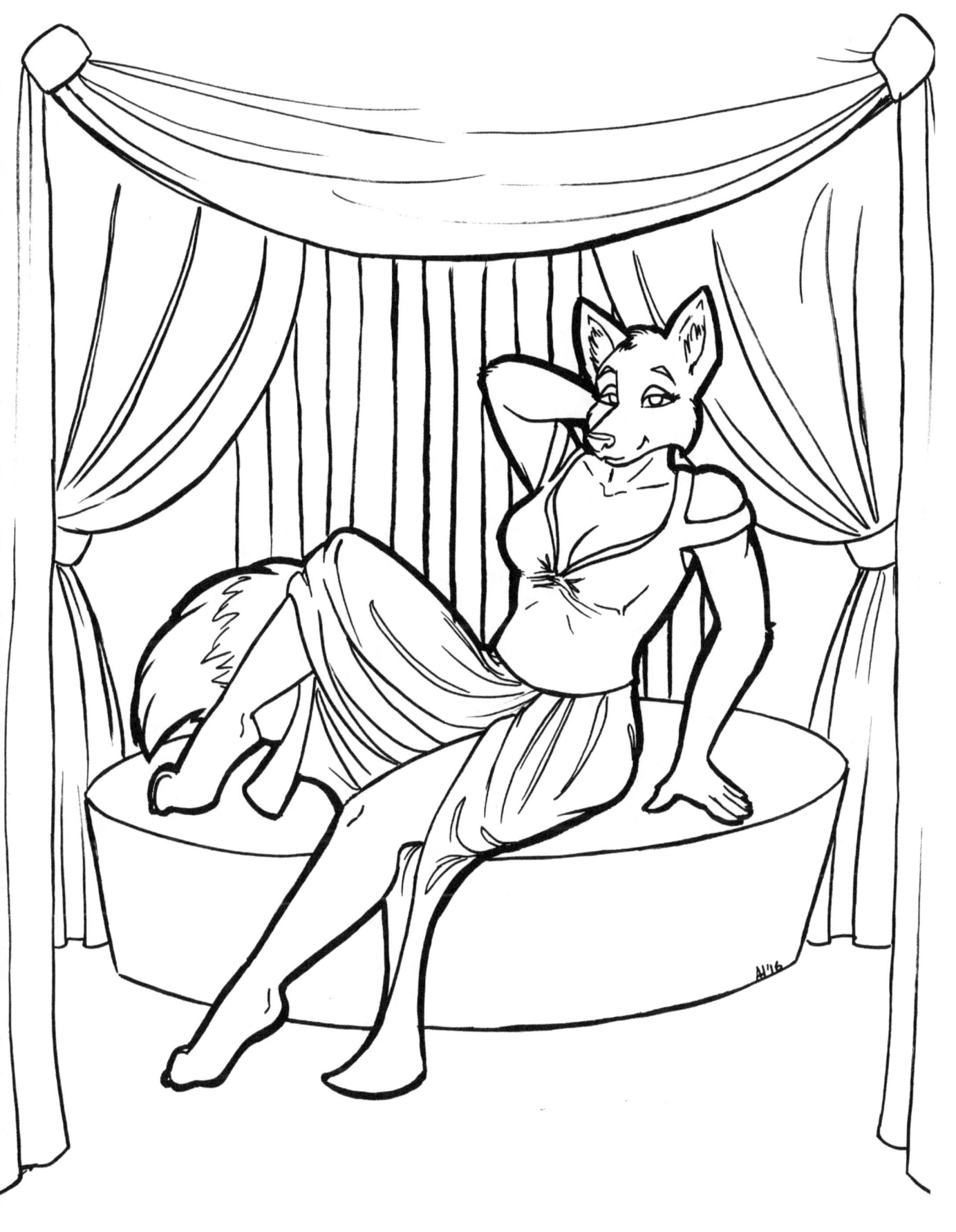

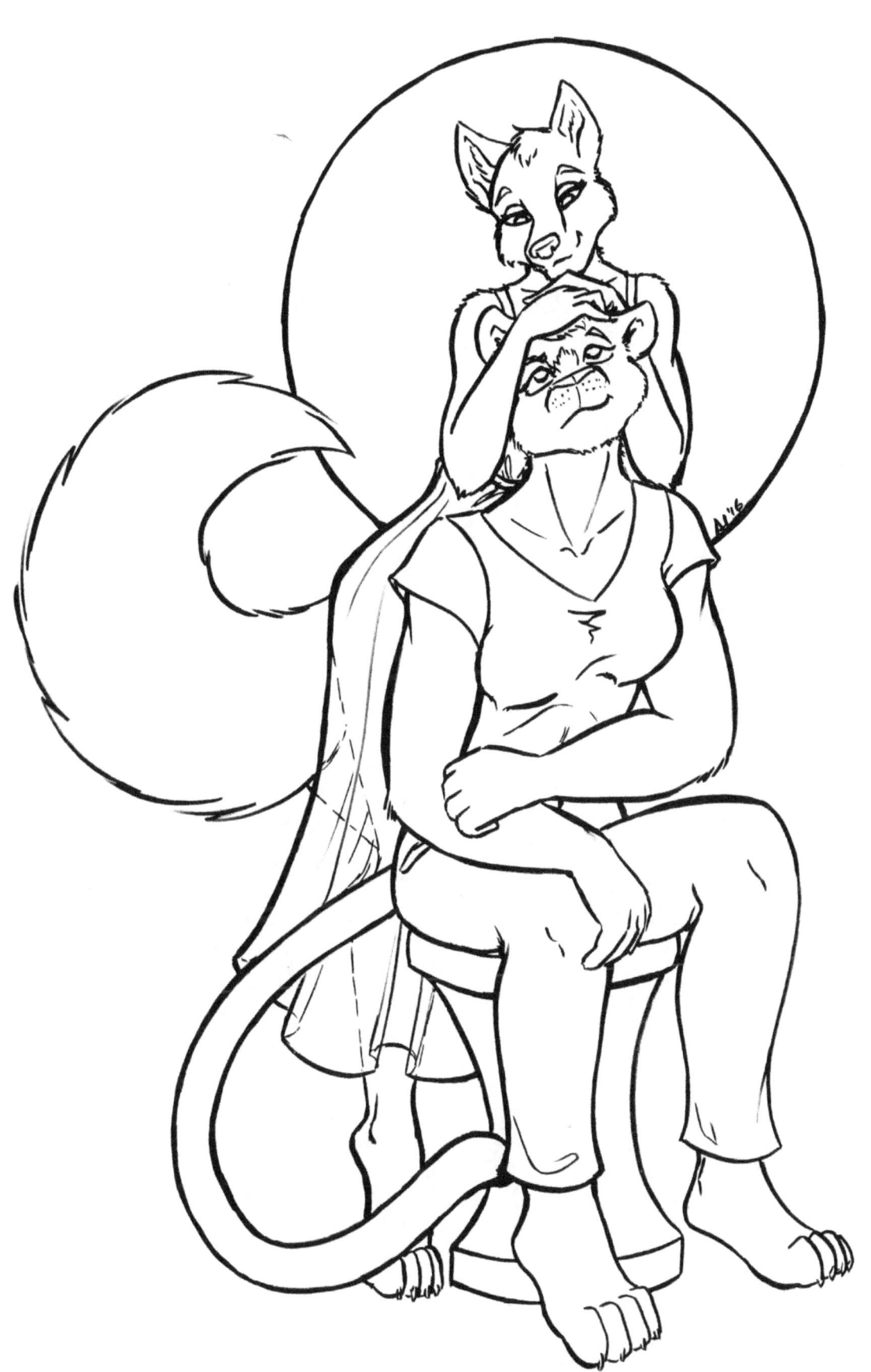

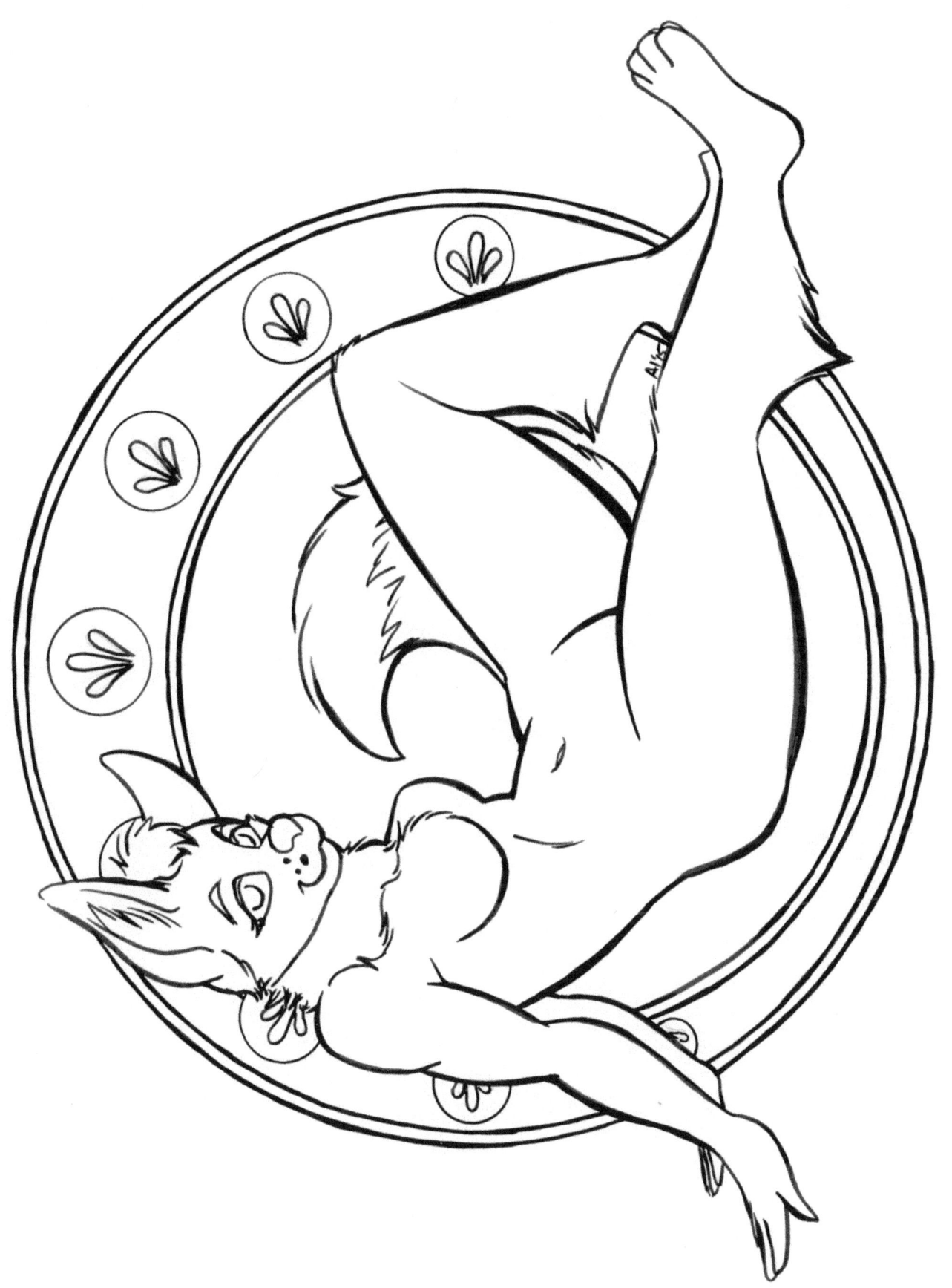

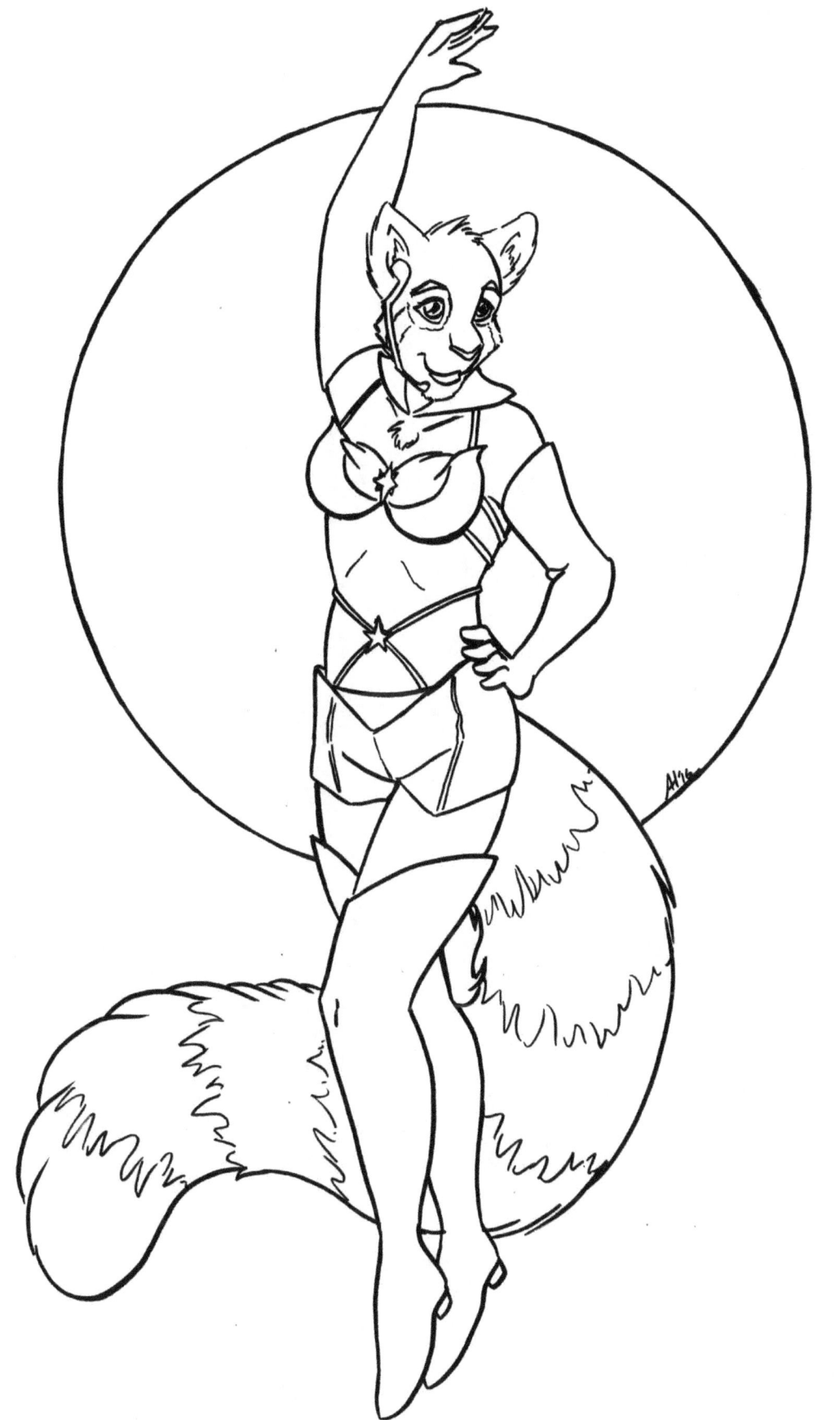

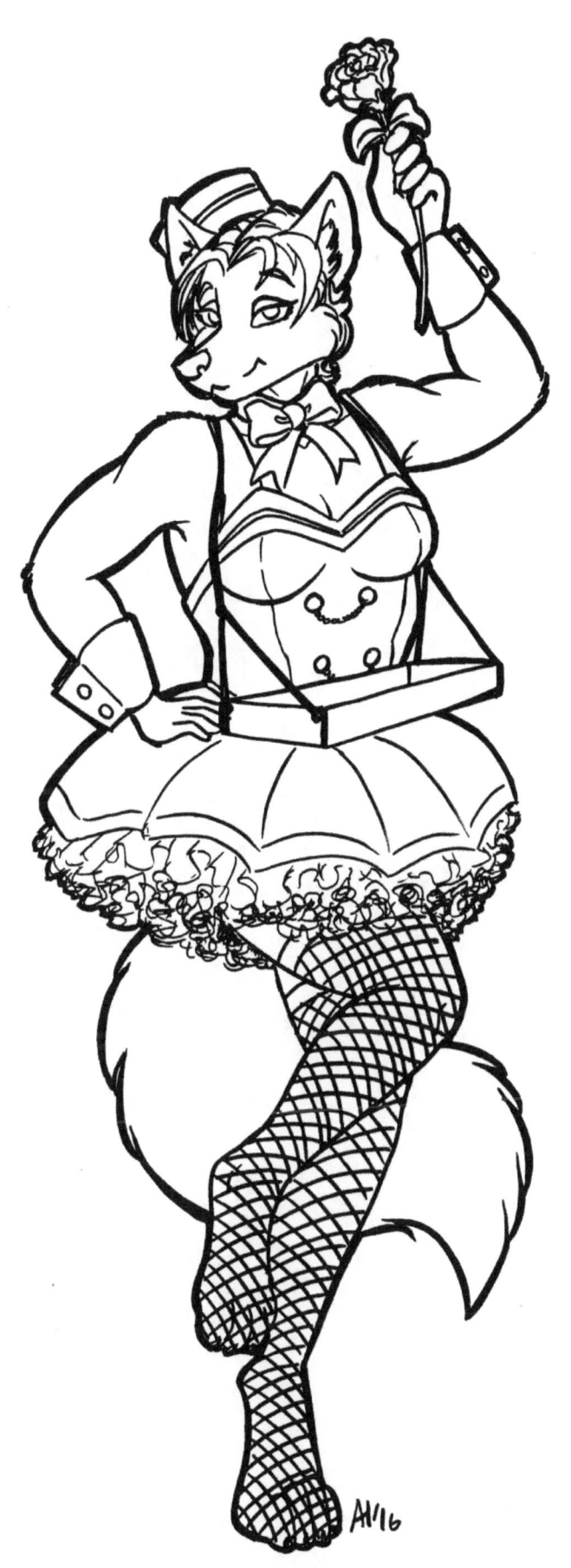

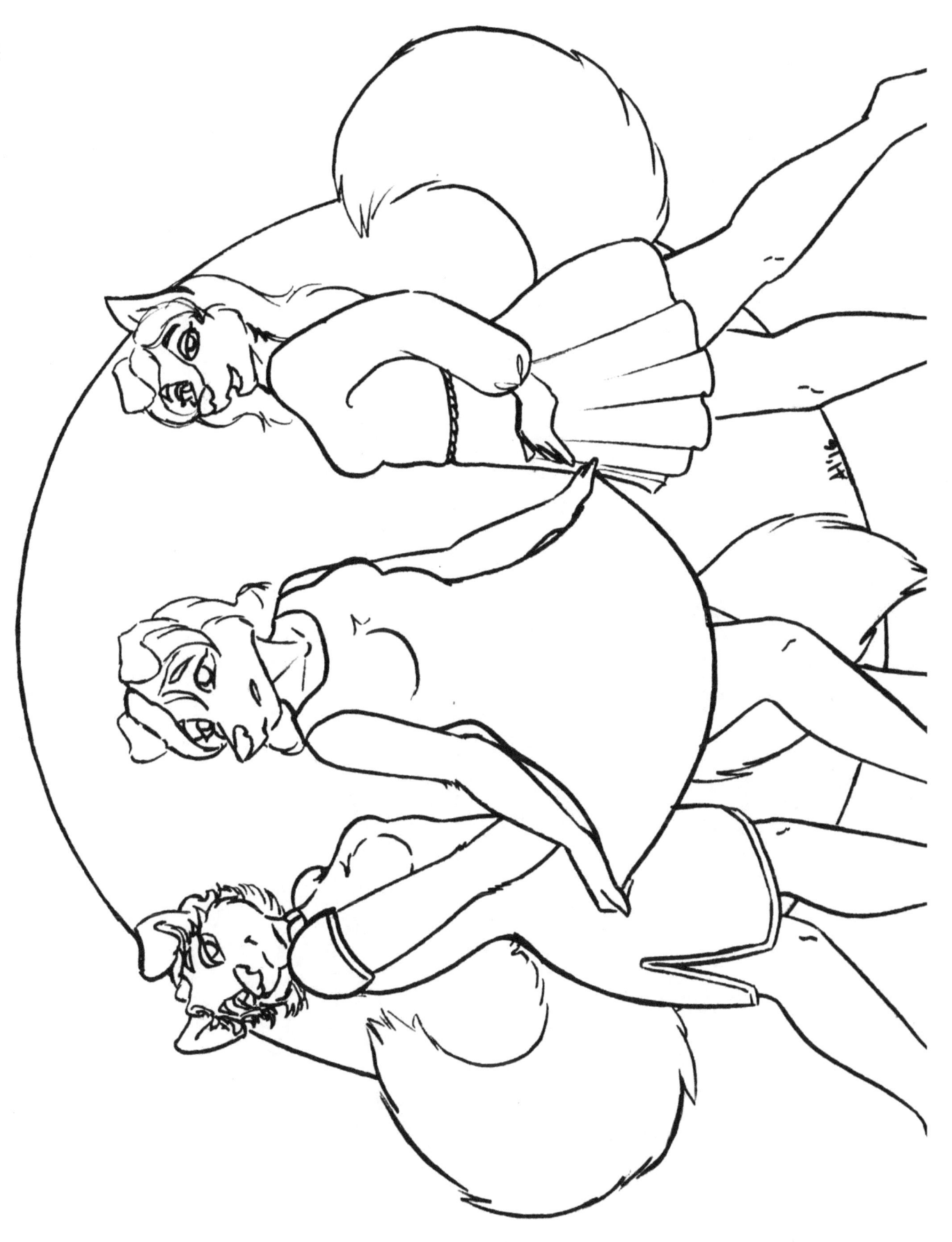

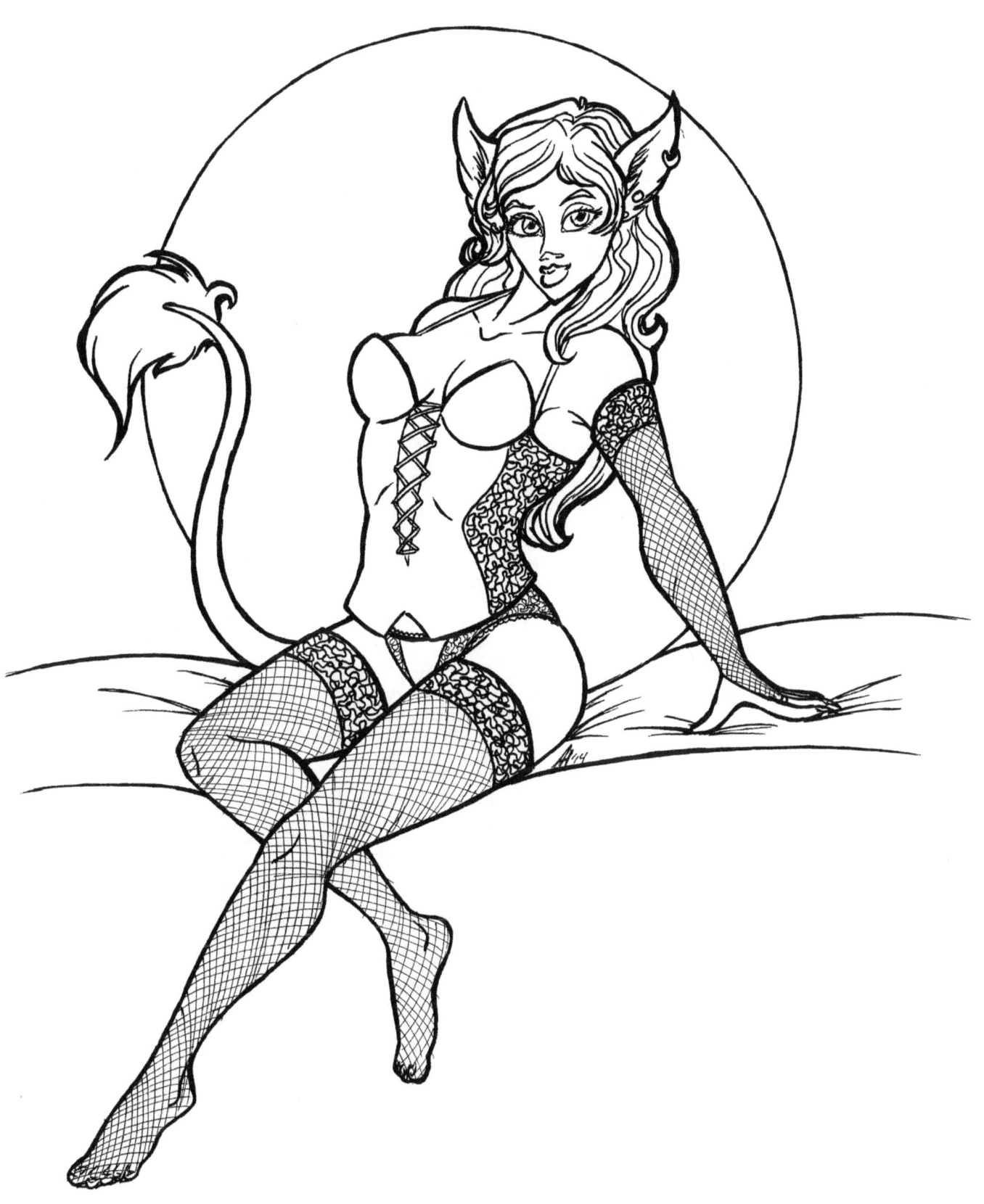

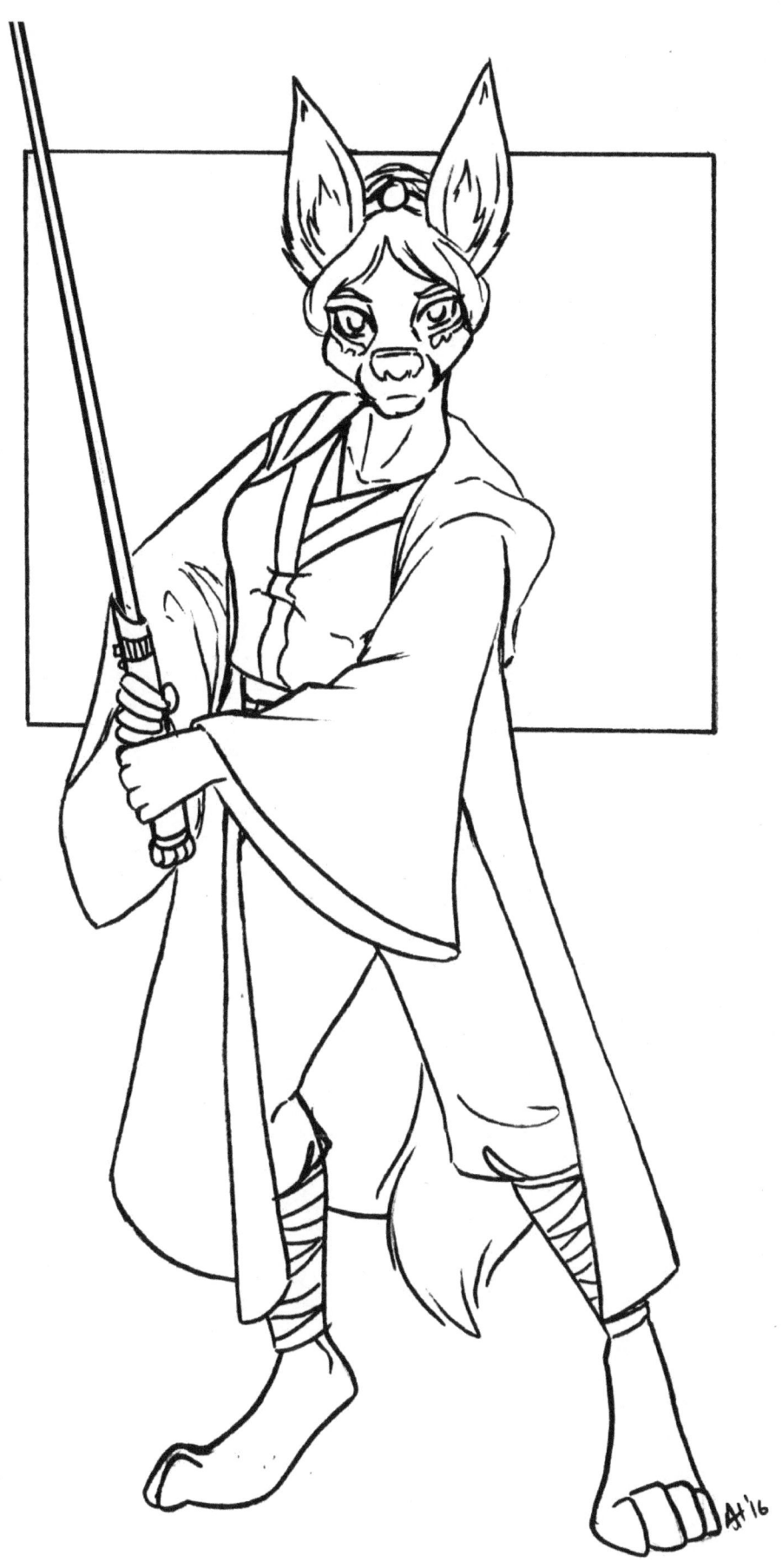

THE ART IN THIS BOOK IS PUBLISHED UNDER A CREATIVE COMMONS ATTRIBUTION, NON-COMMERCIAL, SHARE-ALIKE 3.0 LICENSE! MORE DETAILS AT THE FOLLOWING LINK:

HTTP://CREATIVECOMMONS.ORG/LICENSES/BY-NC-SA/3.0/

WANT TO SHARE YOUR MASTERPIECE?
SEND YOUR COLORED DRAWINGS TO:

ASHLEY@ALOPEXSTUDIOS.COM

OR TAG ME ON TWITTER:

@ASHOLOHAN

YOUR COLORING MAY BE REPRODUCED PUBLICLY, AND YOU WILL BE CREDITED, UNLESS YOU DON'T WANT TO BE.

FIND MORE OF MY WORK AT:

HTTP://WWW.ALOPEXSTUDIOS.COM
OR
HTTP://WWW.FURAFFINITY.NET/USER/ZANNAH

REGULAR LIVE ART STREAMS ON TIGERDILE:

HTTPS://ZANNAH.TIGERDILE.COM

www.ingramcontent.com/pod-product-compliance
Lightning Source LLC
Chambersburg PA
CBHW080717190526
45169CB00006B/2406